creativeGIRL

MIXED MEDIA TECHNIQUES FOR AN ARTFUL LIFE

danielle donaldson

NORTH LIGHT BOOKS
CINCINNATI, OHIO
www.createmixedmedia.com

contents

couchCREATIVE 12

Artsy things to do when you are hanging out on the couch, in the kitchen or on the road.

colorFULL 24

Working with big watercolor palettes and patterned paper.

layerGOODNESS 38

Adding depth to your art with light, shadows and lots of cool layers.

silentTYPE 60

Storytelling through art with little or no text.

creativeGIRL 76

Creating girls that channel your stories.

hotMESS 96

Learning to walk away when your art takes a turn for the worse and how to come back and make it work.

creativeREPURPOSING 106

Where new ideas buddy up with unfinished projects, artwork gone awry and pretty stuff from the past.

extraLOVE 116

A little glimpse at some of my favorite art.

dedication

This book is dedicated to my favorite people in the world. You know who you are.

But most importantly, Scott, Lauren and Clay.

To my husband, Scott—For always listening to the process about each piece I create and then saying, "Looks good, dear." Every single time. For preparing a multitude of meals while I doodle. For making me leave my studio every once in a while to see the world, not just paint my version of it. And most importantly, for loving me forever, no matter what.

To my sunshine-filled daughter, Lauren. For being one of the best human beings I have ever met in my life. For your eternal sparkly optimism and sassy humor. For displaying more love and energy in an hour than most do in a day. And for your fierce determination to work through the hard stuff and grow into an even better version of you.

To my old-soul son, Clay. For taking the time to call me and tell me your stories, then listening to my stories, then telling me you love me before we hang up. For recognizing my everyday limitations but reminding me my creative side is without limits. For telling me that it isn't about what I draw and paint, it's how I draw and paint it that matters most. And for hanging onto the sensitive part of yourself, even when the world thinks you shouldn't.

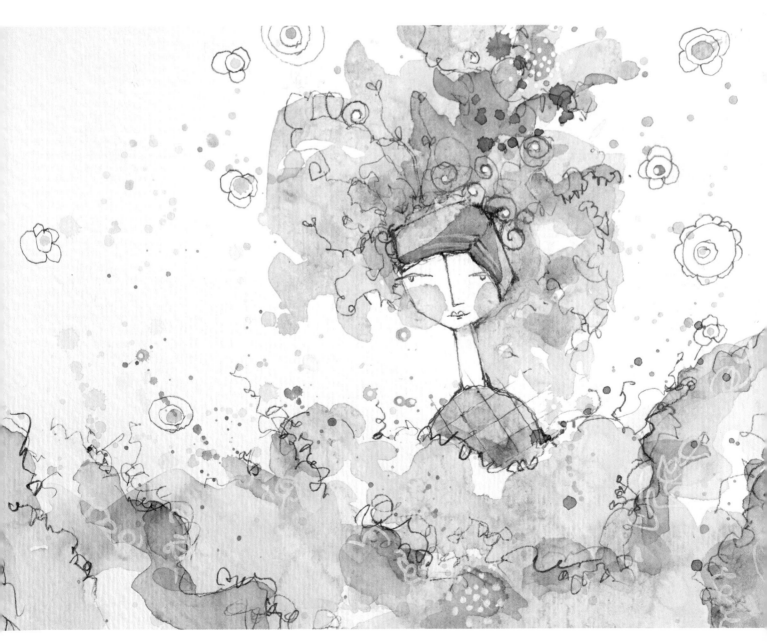

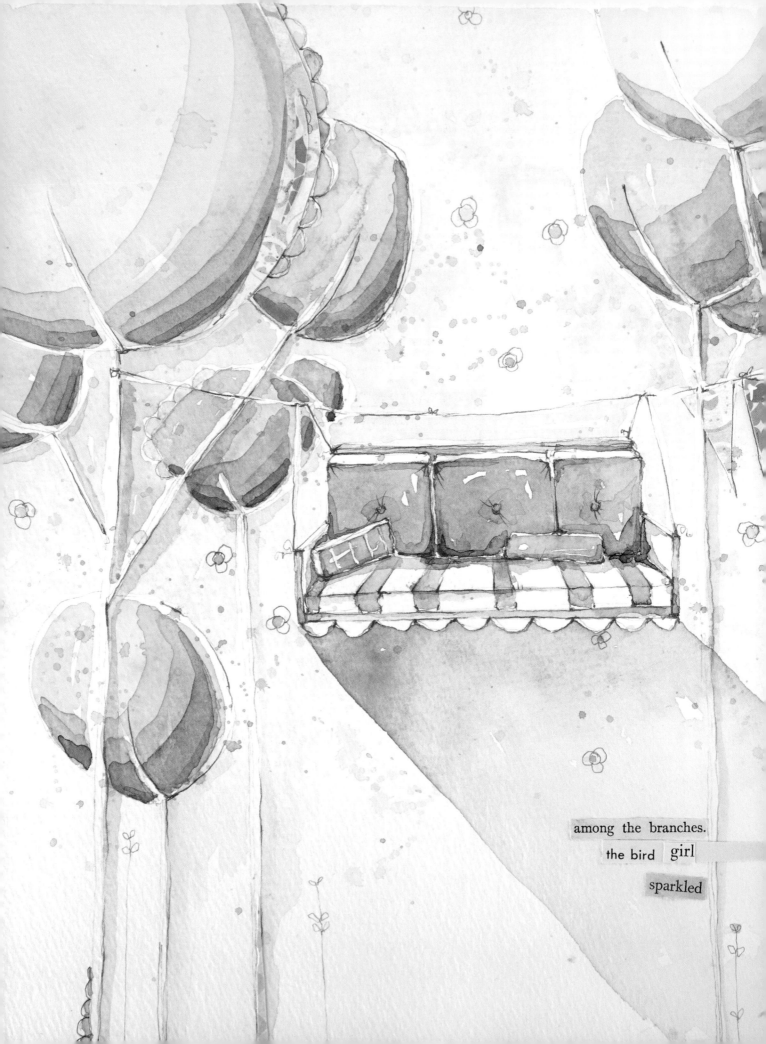

among the branches.
the bird girl
sparkled

introduction

Discover your very own creative happy place in between the covers of *creativeGIRL*. That place where your color-filled imagination meets up with your everyday life. You'll learn to organize your time, personalize your process, create colorful creative stashes and organize your supplies in new ways to help you infuse every day with creative time.

In this book, you find out how to do all of the following things:

- Grow as an artist by allowing the reality of your day-to-day to work with your process instead of against it.

- Recognize when you are stuck and why, and learn how to problem solve with confidence, grace and a good attitude.

- Organize your practice in a way that helps you gain focus and allows you to practice specific subjects and techniques, preventing you from being overwhelmed.

- Illustrate objects on a small scale, leaving the realism behind and imagining *big*.

- Create colorful watercolor stashes and art stations throughout your house and for your travels. Let go of the need for color charts and just play with color and techniques, and bring awareness to what you love and what works for you.

- Find a balance between the need to match the picture in your head to what is in front of you (and accept that it's OK to have a picture in your head to go by).

- Tuck your stories in the layers of your work by mixing the old and new with thoughtful layers of color, pencil work and delicate details.

- Overcome the need to fill up all the space by embracing the awesomeness of white paint, white space and white ink.

- Pay attention to common creative threads in *your* work that can be turned into your signature style.

- And, most important, learn to appreciate the unpredictable nature of watercolors and the unplanned beauty it offers you in your creative process.

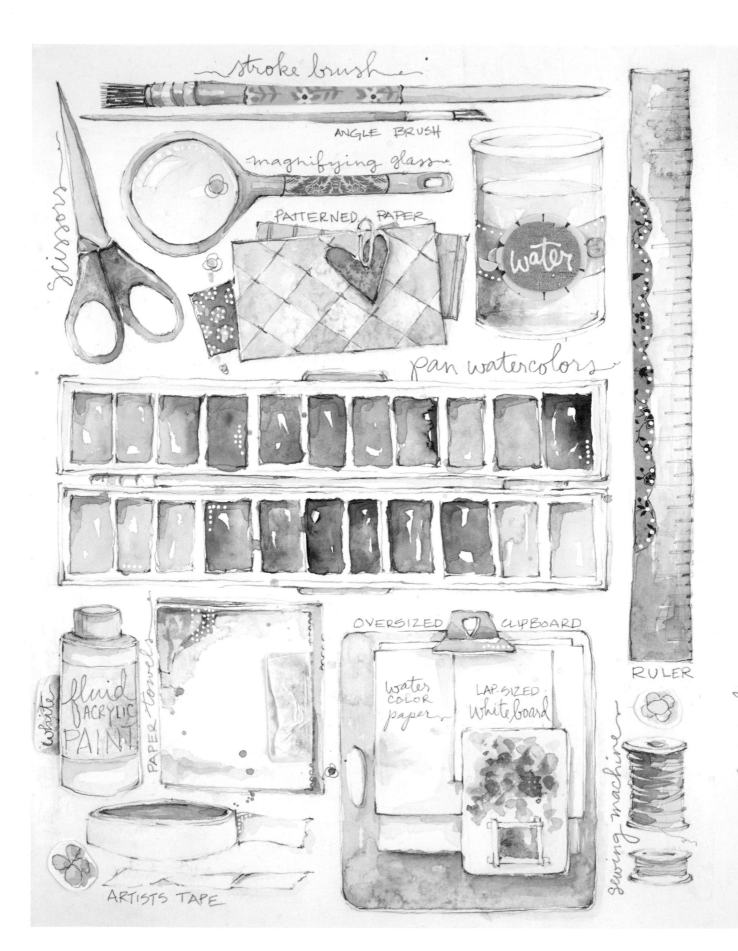

stroke brush

ANGLE BRUSH

magnifying glass

scissors

PATTERNED PAPER

water

pan watercolors

fluid ACRYLIC PAINT

white

PAPER TOWELS

OVERSIZED CLIPBOARD

water color paper

LAP-SIZED whiteboard

RULER

sewing machine

mechanical PENCIL

ARTISTS TAPE

supplies

WHAT YOU NEED

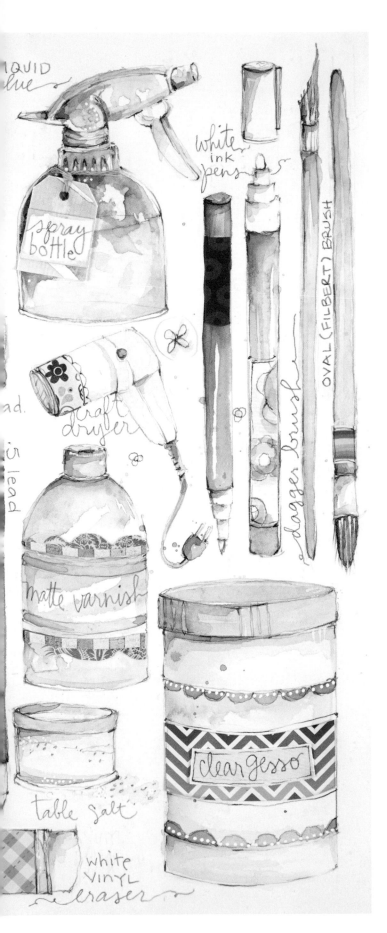

Drawing/Painting

acrylic glazing medium

clear gesso

Dr. Ph. Martin's Hydrus
Watercolors

Grumbacher transparent
watercolor pan set

Derivan liquid pencil

liquid matte varnish

mechanical pencils

Mod Podge

Sennelier pan watercolors

watercolor brushes

white fluid acrylic paint

white ink markers

Paper

book pages

Bristol paper

newsprint

patterned paper

sheet music

sketch paper

watercolor paper

words cut out of books

Tools

brayer

craft dryer

craft knife

hole punch

magnifying glass

ruler

sewing machine

scissors

Miscellaneous

artist tape

birch panels

clear craft glue

craft rhinestones

coffee filters

cotton swabs

fabric

file fasteners

file folders

foam brush

foamcore board

glass jars

key rings

lace and ribbon
scraps

lap-sized
whiteboard

liquid adhesive

Mod Podge

oversized clipboard

paper towels

pushpins

sandpaper

spray bottle

table salt

tray with smooth
bottom

washi tape

white vinyl eraser

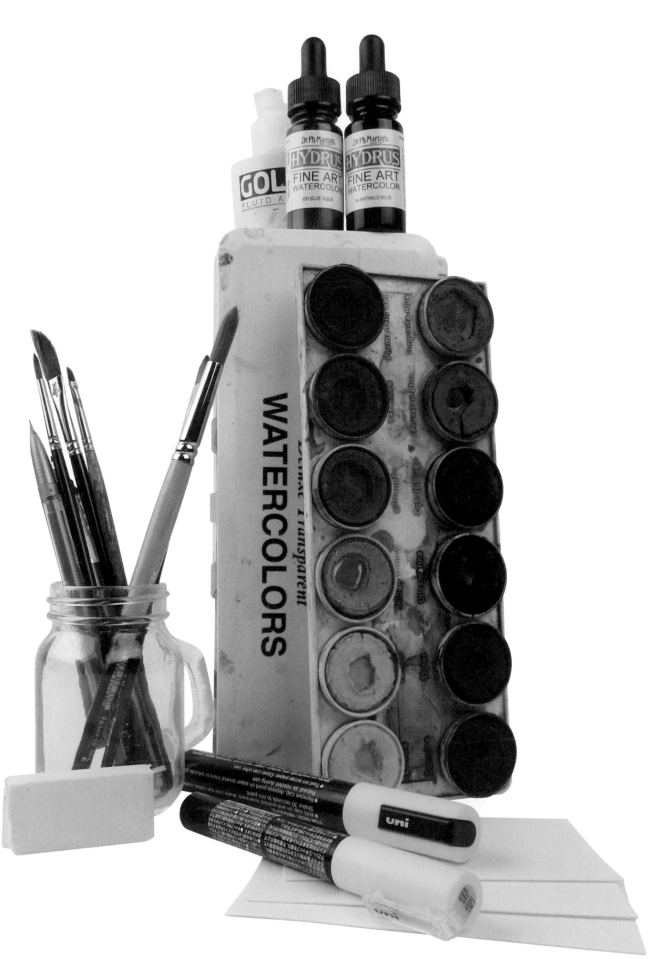

Visit CreateMixedMedia.com/creativeGIRL for bonus demonstrations.

WATERCOLOR PAPER

I am partial to tape-bound pads of watercolor paper that are easy to cut down to whatever size I may need. The paper should indicate a weight no lower than 140-lb. (300gsm). I use both hot press (smooth) and cold press (rough) equally. If I know there is going to be all sorts of really tiny pencil work, I usually choose hot-pressed paper. If I want to create really pretty washes with lots of color, I work with cold-pressed paper. In the end, I don't put much thought into it and just grab a scrap or whatever pad is closest.

My favorite? Canson Moulin du Roy Watercolor tape-bound pads (140-lb. [300gsm] hot and cold press). It holds its shape and absorbs color well.

WATERCOLOR BRUSHES

I follow a few basic rules when it comes to watercolor brushes. First, do *not* use your watercolor brushes for anything other than watercolors. Next, the longer the bristles, the more water they can hold. I have a tendency to load a lot of water and paint into my brushes so I prefer oval (filbert) or dagger brushes because I can hold the brush at different angles to cover big and small areas. They also allow me to splash on water and paint to add more interest to my painting. For straight lines and tight areas, I use angled brushes. If I want to fill in a background around an illustration, I use a stroke brush. As you progress in working with watercolors, you will find that you may gravitate to one or two shapes and sizes and rarely use the rest. Brushes just aren't a one-size-fits-all kind of thing.

My favorite? I love them all. I tend to favor oval, dagger and stroke brushes.

WATERCOLOR PAINTS

I seem to be drawn to two types of watercolors: pan and liquid. I began painting with tube watercolors oh-so-long-ago but have since discovered that pan watercolors pack just as much of a color-filled punch and have the added benefit of portability. There is a plethora of pan watercolors to choose from, and I suggest finding a middle-of-the-road transparent set for your budget to ensure a good number of colors and color saturation.

Liquid watercolors are also portable, and a little goes a long way. The color is dazzling on paper, although I think it works best in small amounts. There is a ton of science behind each type of watercolor, and it will take some experimentation to figure out what works best for you.

My favorites? Grumbacher transparent watercolor pan sets, Sennelier pan watercolors and Dr. Ph. Martin's Hydrus liquid watercolors.

PENCILS

I illustrate with mechanical pencils. I find that they give me the most consistent lines, and let's face it, I am all about avoiding the pencil sharpener in the middle of an illustration. I use three sizes of leads: 0.3, 0.5, and occasionally 0.7mm.

It doesn't really matter what brand it is as long as the lead is the size that I want. There is no need to spend a lot of money on fancy mechanical pencils. Seriously.

My favorite? Any brand that I can find with a 0.3mm lead. These are delicate and require a pretty light hand but always give me the best micro-details. Don't forget a good white vinyl eraser! The erasers that come on the end of the pencils don't last for very long.

WHITE MARKERS AND PAINT

No need to worry about black pens with my art, but I love a good white marker! If you have worked with mixed-media pieces, you know how hard it can be to find a white marker that covers well, doesn't get gummed up and consistently works. I am a collector of white markers and am constantly trying new brands and nibs to use on my watercolor illustrations. It is all about finding what works best for you. I have found that if one isn't working for me, I will use a good angle brush (not my watercolor brush though!) and white fluid acrylic paint. It's a little more work, but it is very reliable.

My favorites? Uni Posca white paint marker (bullet and extra fine) and Golden Titanium White fluid acrylic paint.

ACRYLIC MEDIUMS

To add layers of watercolor, patterned paper and pencil over my work, I use an even mixture of acrylic matte varnish and acrylic clear gesso. While both are water based, I have found if I use a gentle touch I can spot preserve areas or cover the entire piece with little movement. I will be the first to say that this is not a perfect science, but it gets easier with practice. I promise.

My favorites? Liquitex's clear gesso and liquid matte varnish, as well as Golden Acrylic glazing medium.

PREPARATION

I always use artist tape to tape an even border around all four sides of a piece of watercolor paper on my oversized clipboard or a lap-sized whiteboard. Both allow me to roam around the house or take art with me on a trip. I can also turn them on their side or upside down to work on different parts of the illustration with a fresh perspective without smudging my pencil or dragging my hand through a wet wash. The lapboard also allows me to mix colors directly onto the board. This is especially helpful when working with liquid watercolors.

ALL THE OTHER STUFF

A small spray bottle filled with clean water is handy to spray on your pan watercolors to get them moving. Doing so makes it easier to pull color with your brush.

Keep clean water in a jar. The key word is "clean," people! It helps to use a clear jar as a reminder to change the water as often as possible. You would be surprised by how drastically dirty water changes the colors on your palette. You can also screw a lid on the jar and it can move with you!

If I am working on a particularly small illustration of a girl, I use a magnifying glass to be sure I get all the parts in the right places. It prevents a lot of angry, wonky-eyed girls!

I rarely use a ruler, but on the rare occasion that I need to draw a really straight line as a guideline for an illustration, I like to have one handy.

I never paint with watercolors without a scrunched-up paper towel in my hand. *Never*. It helps me get just the right amount of water loaded on a brush, dries my brush, cleans my palette and even makes for some beautiful scraps when I am done! Rags just don't cut it.

My favorite technique for enhancing watercolors is to sprinkle table salt on washes while they are wet. The most magical things happen. I always have a mason jar full of table salt handy. And if I am traveling, I will fill a mini envelope with salt, seal it and then tuck it into my travel case.

I usually attach a few pretty snippets of patterned paper with a paper clip. They serve as inspiration for color schemes and patterns, and I can use scissors to cut out the perfect shape to hide a multitude of illustrated sins.

I love to turn on my sewing machine to stitch on paper scraps, punched shapes, words and other ephemera. These add an amazing amount of depth and visual interest to my work.

creativeGIRL Go-To Kit

Here is a handy list of the supplies and tools I always have with me. Designate a portable bin or tray and create your very own creativeGIRL go-to kit. This creative supply kit includes the essentials to prepare for the projects in this book:

Watercolor pan set (Sennelier or Grumbacher), watercolor brushes (¼-½" oval, dagger, round and angle), container of water, spray bottle with water (to prime the pan palette so it's easier to grab color), paper towels, mechanical pencil, table salt, white vinyl eraser, white paint markers, watercolor paper, artist tape, lap-sized whiteboard and oversized clipboard.

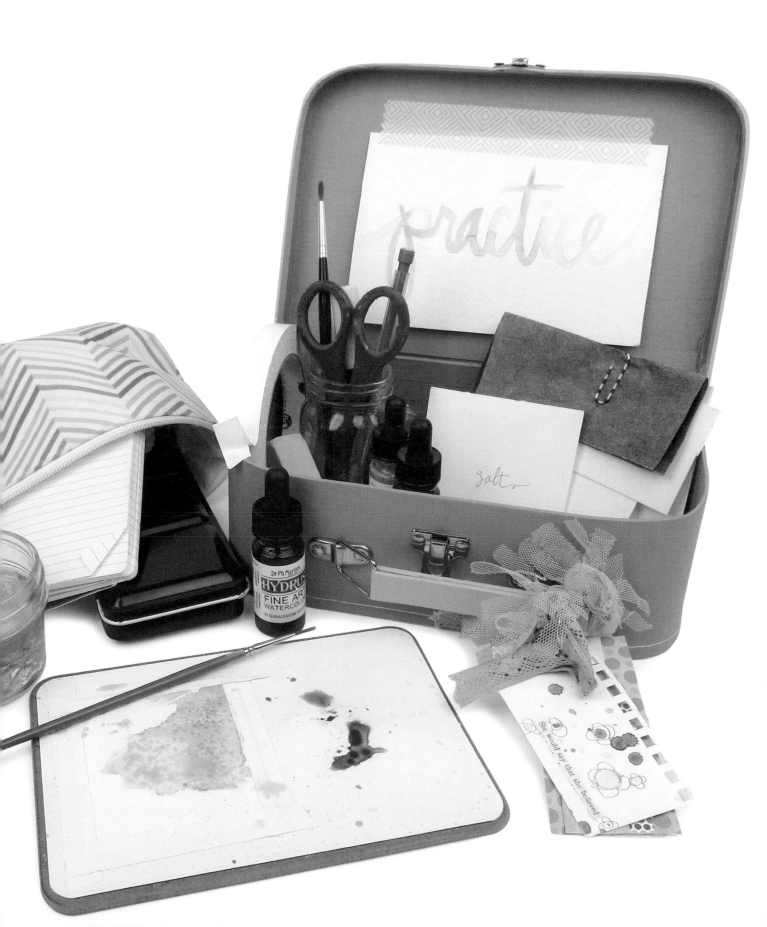

1

couchCREATIVE

I would like to create a pretty picture in your head about the beautiful retreat I have carefully crafted in one of my spare bedrooms: a space where I set aside huge blocks of time to be the creative girl I was meant to be, a space where I quietly click the door shut and practice my drawing skills and invent amazing art layer by layer. But in reality most of my time creating is tucked in between real-life stuff, like a full-time job, a house that is constantly in need of dusting and quality time with the people I love most. It isn't about my lack of planning. Grabbing time here and there is a purposeful way to clear my mind—a creative meditation of sorts that hits the reset button, allowing me to transition back to reality with a little more pep.

My favorite place to immerse myself in artsy goodness is on my couch. I love that I am able to sit with my husband while he watches sports (of course). It is truly my happy place. I can grab scraps of watercolor paper and imagine new creative girls. I can pull out my inspiration folder and practice drawing profiles or tree houses or even hand-lettering. No perfectionist strings attached.

To capture or practice my art during my little bits of free time or at the end of a busy day, I have little stashes of creative tools in almost every corner of my world: the kitchen, the living room, the car, my purse and even in my suitcase. I'll give you my favorite combinations of supplies to create your own stash stations, which is a favorite project for me, by the way, because it allows some easy crafting time as well.

Once you have created your very own stash stations, I will share my two go-to illustrative practice projects. Each project will help you become a better illustrator by grouping similar objects, working on small-scale drawing, using an especially awesome technique that I refer to as "visual tension" and, of course, stretching your imagination. We all should spend a bit more time just imagining, don't you think?

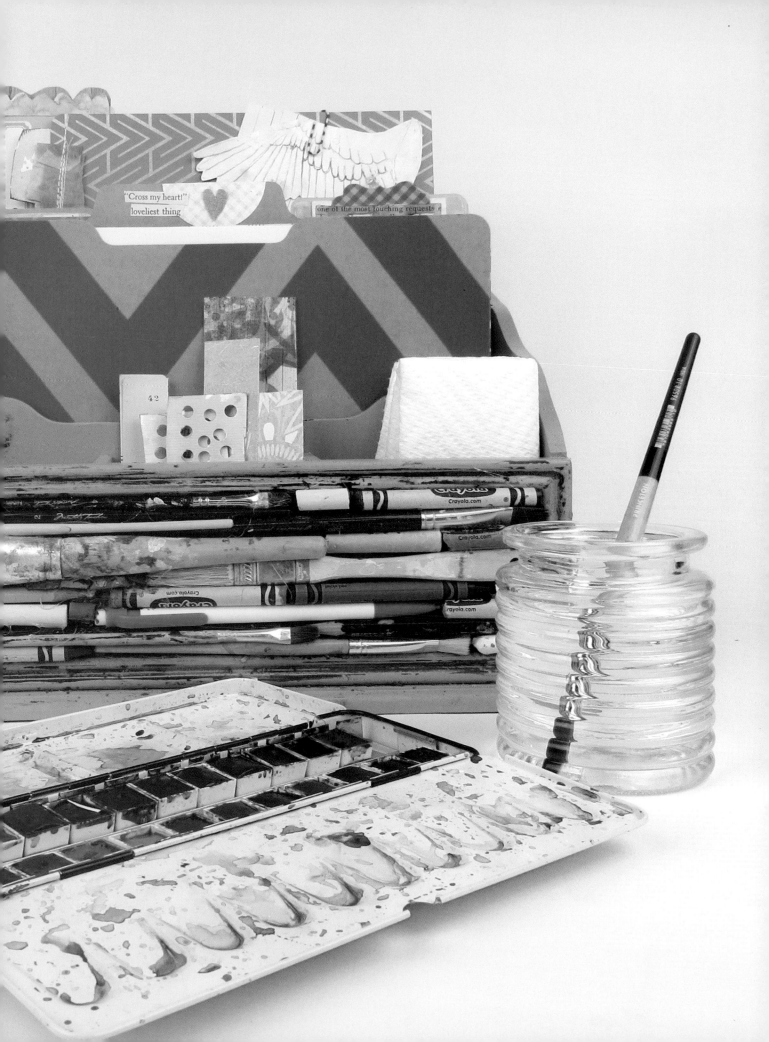

stash stations

I love long, lazy Saturday afternoons in my creative corner of the house, otherwise known as "the dorm room," although they are not scheduled as frequently as they should be. I unwind, refocus or distract my busy brain with small snippets of creative time throughout the day and week. I have been known to start in the dorm room in the early morning before work, then draw the details in the kitchen while my husband cooks dinner and eventually move into the family room to add the finishing touches while we watch TV. I find that my pieces move forward when I leave gaps of time to imagine the next layer and work through things that didn't turn out the way I wanted. To accommodate my creative roaming, I have put together "stash stations" in different corners of my house, along with a few travel versions to entertain myself on road trips and train rides, too.

For me, daily creative practice is a must, and among my favorite creative organization tools are my inspiration folders. Sometimes blank bound journals can be overwhelming. I am always worried I am going to create my favorite masterpiece ever and not be able to copy it or frame it. Silly, I know, but I am sure I am not the only one with this concern. I prefer to use loose paper of all sorts and to tuck them into subject or skill-specific folders. These folders gently push me to focus on practicing specific skills or subjects like drawing all sorts of ellipses for jars, buckets and even tree trunks. I love ellipses.

MATERIALS LIST

- clear craft glue
- decorative file folders
- file fasteners
- file folder labels
- inspiration sheets
- loose sketch or Bristol paper
- scraps of patterned paper
- two-hole punch
- words cut out of books

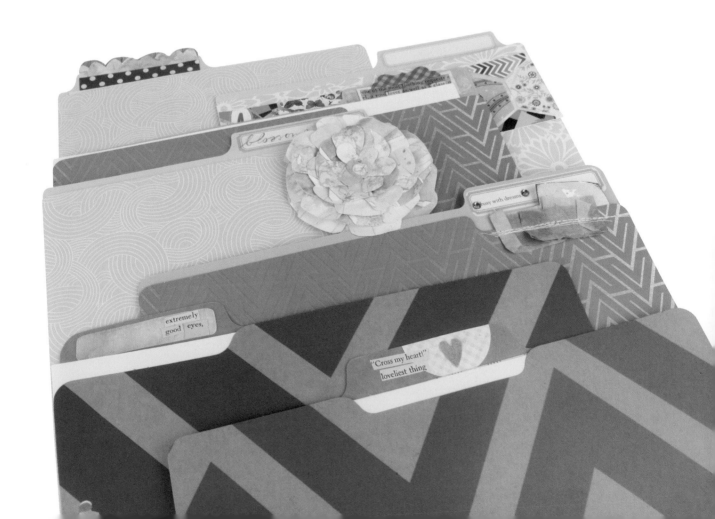

1 Start Making a Folder

Gather up your supplies to create a variety of inspiration files based on a theme or subject. Use your two-hole punch on both sides of the folder.

2 Add a Fastener

Attach metal file fasteners. These allow you to add paper and any printed inspiration you like. You can easily take out practice sheet failures and add new inspiration sheets over time.

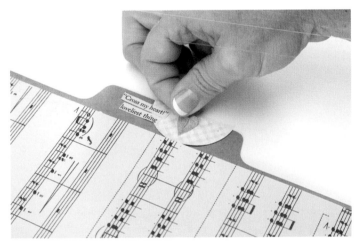

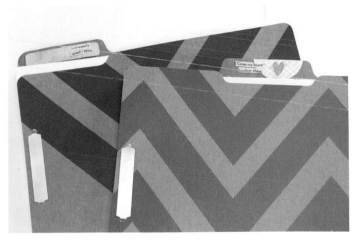

3 Decorative Details

Use a variety of scraps from your stash along with words from your word jar (refer to storytelling and word jars in chapter 4 for more). Layer and adhere them to the folder.

4 Finishing Touches

Finish up any other decorative details you want to add to the folder, then repeat with another folder. Soon you'll have your very own stash.

CREATING A LABEL

Be creative! Use a pieced-together phrase or pretty hand-lettering for your label. It only needs to make sense to you!

couch doodles

Doodling on a small scale gives you the opportunity to practice a more illustrative drawing style. Moving away from re-creating realistic dimension and details, you can simplify and concentrate on imaginative details. A good rule of thumb is that each object should be the size of, well, smaller than your thumb! In addition, I like to group objects by subject: things that are in the sky, kitchen utensils, trees and forts. Once I have drawn a pretty little group of objects, I add visual tension, a process of creating depth and visual interest with my mechanical pencil. Last, I practice my hand-lettering and add titles and labels. Have I mentioned I love hand-lettering? Let's practice a bit, shall we?

MATERIALS LIST

Bristol paper, printer paper or sketchbook

mechanical pencil (0.3 and 0.5mm lead)

white vinyl eraser

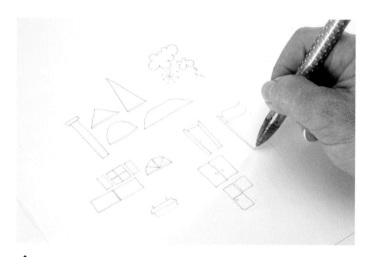

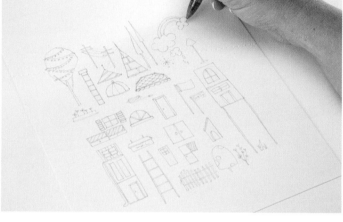

1 Create Basic Shapes
Start doodling small shapes with your mechanical pencil. Try not to press too hard into the paper. You want to be able to erase and try again. Remember, this is practice and our goal is never perfection! Draw different shapes for house frames, roofs, windows and doors, and don't forget little things like lampposts, mailboxes, trees and flowerpots.

2 Add Details
Once you have completed the basic outlines of your bits and pieces, use your imagination and add details to the different shapes. Keep in mind that the details don't need to make sense. Add scallops to windows, stripes on tree trunks or a ladder to get to the second story of a tall, skinny house.

3 Add Labels
Add visual tension using your mechanical pencil by going over lines again and varying the width of the lines and pressure on the page.
 Last but not least, add some delicate hand-lettering to your grouping with a title and subgroup titles such as "roofs," "windows" and "doors." It's great practice and often turns a practice page into its own little work of art! (And sometimes it just reminds you what the heck you were trying to draw in the first place.)

IMAGINATIVE PATTERNS

Try lots of different patterns: scallops, plaid, stripes, argyle, polka dots, swirls, chevron, bricks, waves, starbursts, blooms.

GROUPING IDEAS

- pretty in pink
- coffee and doughnuts
- everyday art supplies
- under the sea
- unicorns and rainbows
- birdcages and nests
- camping under the stars
- jars, buckets and baskets

4 Put It All Together

Take the individual doodles and shapes you have drawn and combine them into a piece of art. Pull shapes from the window and roof groups to create a house.

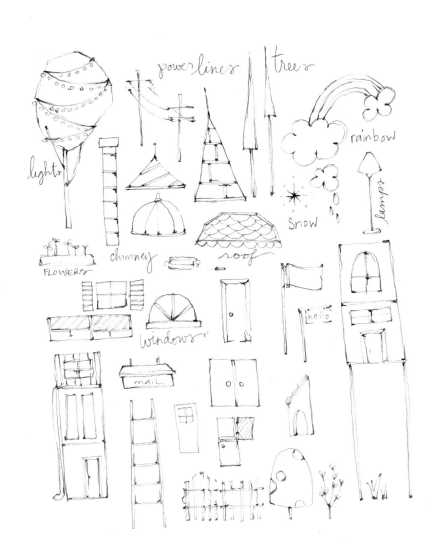

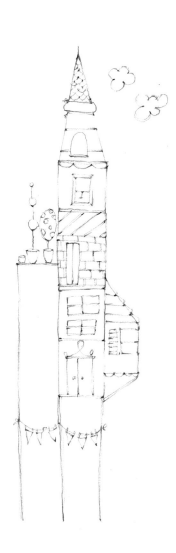

mirror image doodles

It's time to take our doodling up a creative notch! Have you ever noticed how you automatically draw specific objects in the same direction every time? For example, when I draw a profile of a horse, its head is always on the left. Always. My illustrated girls almost always look off to the left side of my paper. It's an ingrained habit. To break this habit, I have created a practice that forces me to draw a mirror image for a series of small illustrations. It's surprisingly hard and amazingly satisfying. The practice reminds me that there is always room to grow as an artist, even in the littlest of ways—like changing the direction of a paper airplane in one of my illustrations. And, as a bonus, the mirror images can be really beautiful finished pieces, once you get the hang of them.

MATERIALS LIST

Bristol paper, printer paper or sketchbook

mechanical pencil (0.5 and 0.3mm lead)

white vinyl eraser

1 Create a Starting Point
Draw a circle anywhere on the vertical centerline of your paper. Illustrate the circle and add a word or a phrase that sparks your imagination. Next, draw a small-scale object on your dominant side (right-handed, left-handed). Do your best to draw the mirror image in the same location on the other side of your paper. I suggest starting with simple shapes like arrows, swirls, paintbrushes and feathers. It's OK if they're not exactly the same; you just want the shapes to be similar. Remember, this is meant to push you creatively to try to teach your head and your hands to work in a different way. This exercise is all about trying new things to add a happy twist to your art!

2 Add More Doodles
While you continue to add doodles, moving from your dominant side to nondominant side, pay attention to the shape and variety of the doodles as a whole and fill in accordingly.

COMPOSITION

This exercise has an extra, hidden perk—it trains your eye for overall balance and composition. Pay attention to the white space between each object and around the doodles as a whole. Do you need to practice placing shapes closer together? Do you need to work on scale of objects? If you framed this piece, would there be comfortable white space between the frame and the doodles? Is it top or bottom heavy? The more you analyze your work, the better you will get at drawing illustrations. I promise!

VISUAL TENSION

My definition of visual tension is the amount of pressure or width of line used in the illustration. Notice that none of the lines are uniform, (meaning they don't follow a consistent pattern) although the place where two lines intersect or join together is almost always a bit thicker and heavier.

This is what makes my work mine, a signature of sorts. What could you do to make it yours?

3 Add Visual Tension

Keep building up the piece with mirrored doodles until you're satisfied. To complete your practice, go back and add visual tension to add depth and visual interest.

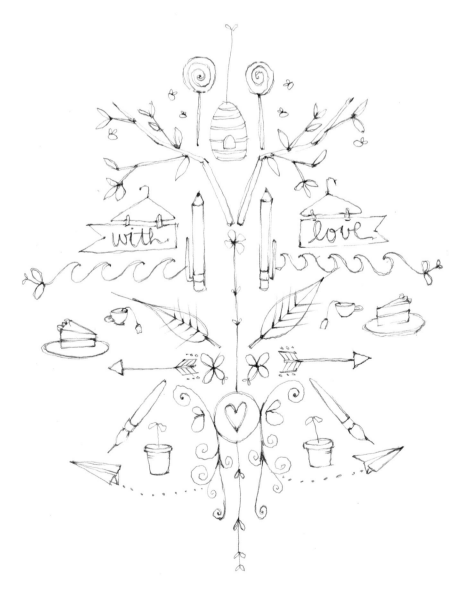

creative challenges

Creative challenges are a way to grow your skills and connect with your friends across the miles at the same time. Some of my favorite pieces have been created based on challenges just like these. I have found that the more detailed the challenge, the better. These exercises force you to focus on specific skills and stretch you out of your comfort zone. Each challenge includes specific mediums or techniques, an inspirational quote and "theme" music.

You can follow my challenges, tweak them or come up with your own. Invite a friend or two, share the rules of the road and make something pretty!

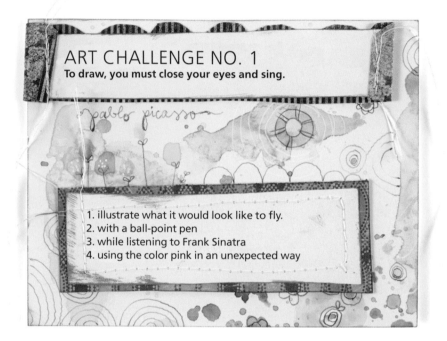

ART CHALLENGE NO. 1
To draw, you must close your eyes and sing.

pablo picasso

1. illustrate what it would look like to fly.
2. with a ball-point pen
3. while listening to Frank Sinatra
4. using the color pink in an unexpected way

For your first challenge, start with one friend. If many friends are involved, it's really easy to make the challenge into a big, overwhelming project. You can end up spending all of your time managing the challenge rather than participating in it.

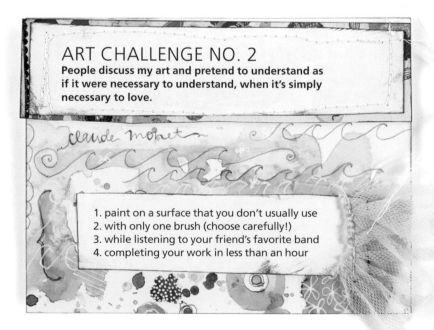

ART CHALLENGE NO. 2
People discuss my art and pretend to understand as if it were necessary to understand, when it's simply necessary to love.

claude monet

1. paint on a surface that you don't usually use
2. with only one brush (choose carefully!)
3. while listening to your friend's favorite band
4. completing your work in less than an hour

Make sure you try the music part of the challenge. I think it makes a huge difference. Notice what music energizes or annoys you. You may also find visual imagery in the lyrics that you can channel into your piece.

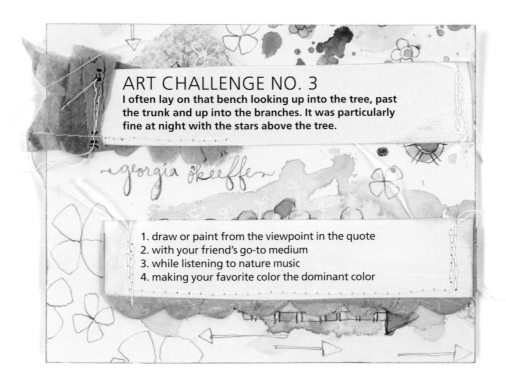

ART CHALLENGE NO. 3
I often lay on that bench looking up into the tree, past the trunk and up into the branches. It was particularly fine at night with the stars above the tree.

georgia okeeffe

1. draw or paint from the viewpoint in the quote
2. with your friend's go-to medium
3. while listening to nature music
4. making your favorite color the dominant color

Set a deadline for a big reveal, and make sure everyone involved agrees to it. If you have a flair for graphic design, you might have everyone send you their finished piece and turn it into a picture collage.

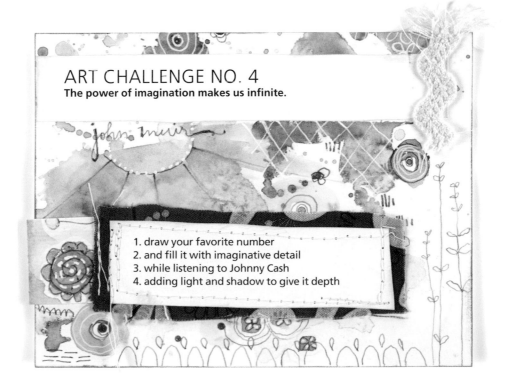

ART CHALLENGE NO. 4
The power of imagination makes us infinite.

john muir

1. draw your favorite number
2. and fill it with imaginative detail
3. while listening to Johnny Cash
4. adding light and shadow to give it depth

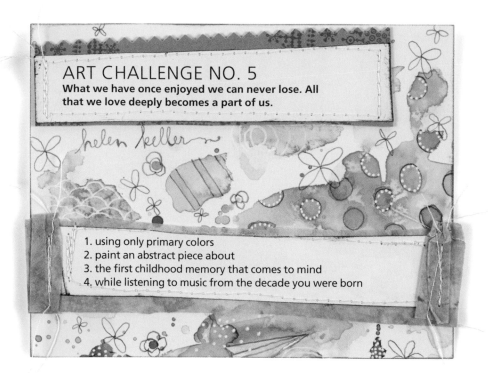

ART CHALLENGE NO. 5

What we have once enjoyed we can never lose. All that we love deeply becomes a part of us.

helen keller

1. using only primary colors
2. paint an abstract piece about
3. the first childhood memory that comes to mind
4. while listening to music from the decade you were born

Create a pretty set of challenge invitations and send them in the mail. Who doesn't love real mail?

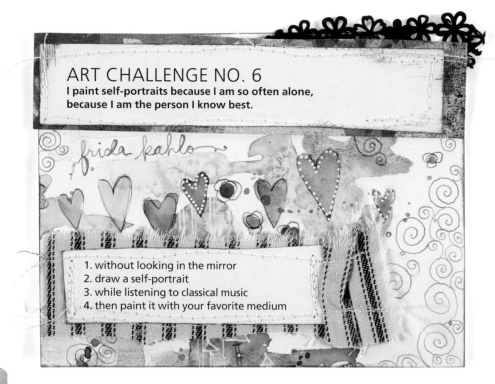

ART CHALLENGE NO. 6

I paint self-portraits because I am so often alone, because I am the person I know best.

frida kahlo

1. without looking in the mirror
2. draw a self-portrait
3. while listening to classical music
4. then paint it with your favorite medium

Connect! Take time to chat with your challenge buddies during the process. The idea of the challenge is to remind you that you aren't sitting alone in your studio. You have faraway friends who love to do exactly what you love to do!

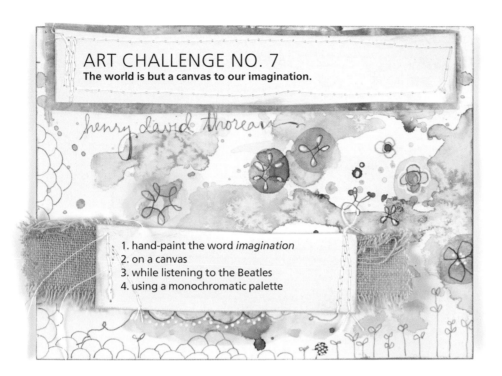

ART CHALLENGE NO. 7
The world is but a canvas to our imagination.

henry david thoreau

1. hand-paint the word *imagination*
2. on a canvas
3. while listening to the Beatles
4. using a monochromatic palette

Have a challenge party! Set a time and date, and ask everyone to post their result online at the same time. Flashes of unique brilliance will magically start popping up in everyone's newsfeed.

Visit CreateMixedMedia.com/creativeGIRL to download and print blank creative challenge cards!

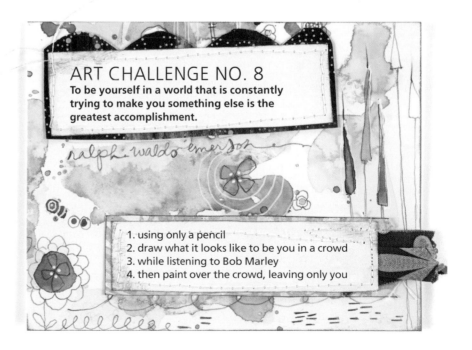

ART CHALLENGE NO. 8
To be yourself in a world that is constantly trying to make you something else is the greatest accomplishment.

ralph waldo emerson

1. using only a pencil
2. draw what it looks like to be you in a crowd
3. while listening to Bob Marley
4. then paint over the crowd, leaving only you

2

colorFULL

I *love* colors. Each and every one of them. There isn't a combination of colors that I can't coax into playing nice together. I am cool like that. It's a part of me. I love pulling out my watercolor pan set, spraying it with water, dipping my brush into pure color, choosing another just to watch the colors swirl together and make magic, and knowing that with a drop or two of another color I can create the perfect addition to my illustration. And then, when I think I have it just right, I throw in an easy technique or two and walk away to let it dry. When I come back, it will take me by surprise—the spontaneous beauty of the process. And I know I will never achieve the same result no matter how hard I try. Happiness sets in knowing that I am releasing myself of the arduous task of repetition and perfection. It sounds like a romance novel, I know. But like I said, *I love color*. And I want you to love color, too. Let's explore the endless possibilities together and start making some rainbow-filled magic.

kitchen sink color palettes

Learning how to work with watercolors can be intimidating. Once you have added color to the paper, there is no going back. For me, that is a good thing, given my proclivity to control outcomes.

It is true that creating color wheels and charts will give you great insight and provide a reference point. It's like sitting on a beach and waiting for the sun to set. You have your camera in hand, and you're looking at the sunset on that little screen and waiting for the perfect moment—when the sun is barely above the horizon line, when the rays catch the light in the waves. You think it will be the best Instagram photo ever. But while you are waiting for the perfect moment, you miss out on so much—the still warm sand between your toes, a soft breeze in your face, the sound of the crashing waves and the smell of salt in the air. Don't just capture the moment; create in it. The real magic happens where you least expect it: colors swirling together, salt sprinkled in, a few minutes of drying time, and what you wanted to happen didn't, but what actually happened is better than you thought it would be anyway.

In this series of exercises, I encourage you to pay attention to the magic and leave the rules of color theory at the door. Watercolors require you to work at a fairly quick pace, so let go of perfection and control, and just have fun!

MATERIALS LIST

cotton swab

craft dryer

creative supply kit (see page 10)

watercolor paper cut into long strips

RAINBOW REFERENCE STRIP

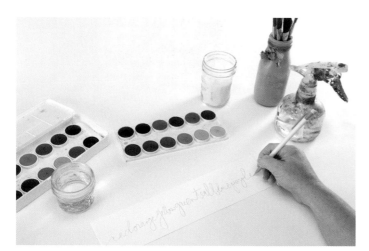

1 Write the Color Names
Spray your pan watercolors with clean water. This will allow you to pull more color from them with less work. Write the colors of the rainbow in the following order in one continuous word: red, orange, yellow, green, teal, blue, purple.

2 Add Color
Wet your brush and swirl it into red to load your brush with color. It may take some trial and error to figure out how much water you want on your brush. We will be working with a wet brush onto dry paper for all of our test strips. Add red over the word red. Notice that I leave a white border around the strip. This allows you to control where your color is going. Clean your brush and move to orange, allowing red and orange to bleed into each other.

Continue adding each of the colors with a clean brush loaded with water, letting them naturally bleed together. Let dry.

RANDOM COLOR ORDER STRIP

1 Write the Color Names

For this exercise, you'll need the exact names of the watercolor for reference. Write the color names on your paper in a random order with somewhat consistent spacing between each. Don't choose the order of colors to control the outcome!

2 Paint Each Color

Wet your brush and swirl it into the first color you have written on your strip of watercolor paper. Brush the paint over the word, leaving a white border around the edges to write notes later. Clean your brush and move to the next color you have written, allowing it to bleed into the color before it. Continue adding each of the colors with a clean brush loaded with water, letting them naturally blend together.

While the strip is drying, notice how the colors interact with each other. Once dry, pencil in notes on the border and circle specific areas you like. These can serve as references for other projects.

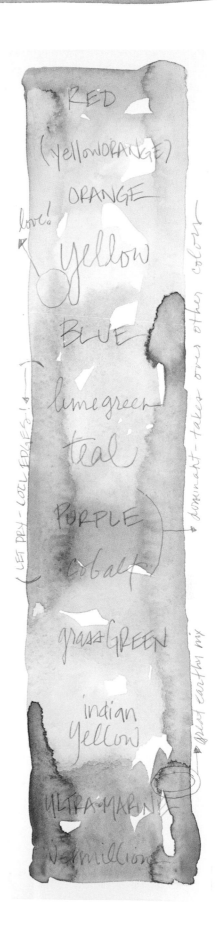

TECHNIQUE STRIP WITH A SINGLE COLOR

For this exercise, write down various techniques of your choosing in a random order. You can repeat techniques in different places or use combinations to experiment further.

Load your brush with a good amount of water and cover the strip, leaving a white border for notes after it is dry. Reload the brush as needed to be sure there's a good amount of color from top to bottom. Work through the techniques listed while paying attention to the results. Allow the strip to dry completely.

After the strip has dried completely, use a soft dry brush or your fingers to loosen and brush away the salt. Add notes to the borders of the strip. Notice how different amounts of water change the result of the technique. Did the specific brush you used flick additional water or paint well? Could you use the paper towel a different way to make a specific pattern?

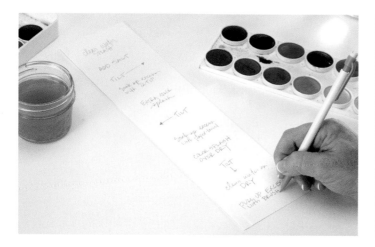

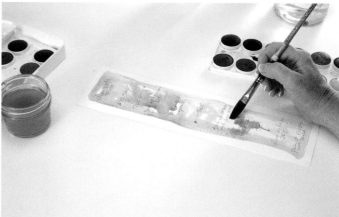

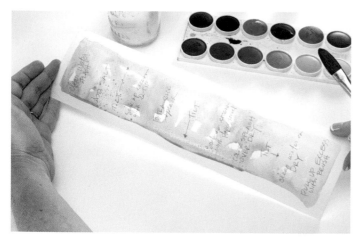

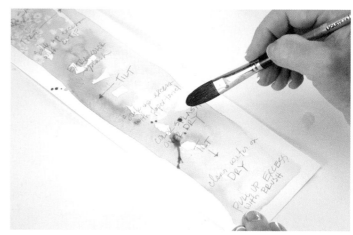

TECHNIQUES TO TRY

Your wash will change with each technique. Try each of these: dropping clear water into both wet and almost dry washes, gently splashing a bit more of the same or different color into wet washes, picking up color with paper towels and cotton swabs, tilting your paper to move washes in different directions, adding sprinkles of salt to wet washes.

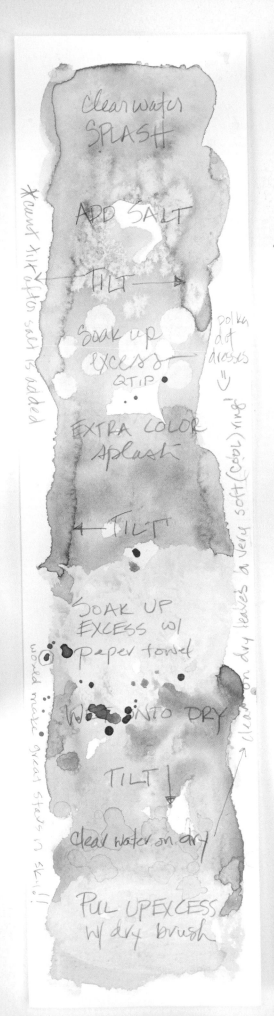

Clear water
SPLASH

ADD SALT

TILT →

Soak up
excess
QTIP

polka
dot
dresses

EXTRA COLOR
Splash

← TILT

SOAK UP
EXCESS w/
paper towel

WET INTO DRY

TILT

Clear water on dry

Pull up excess
w/ dry brush

cant tilt/add after salt is added

worked make great steps in skill!

(leave on dry leaves a very soft (cool) ring!

TECHNIQUE STRIP WITH RANDOM COLORS

For this exercise, write down various techniques and colors in a random order. You can repeat techniques in different places or use combinations to experiment further.

Wet your brush and swirl it into the first color you have written on your strip of watercolor paper. Brush color over the word, leaving a white border around the edges of the paper to write notes later. Clean your brush and move to the next color you have written, allowing it to bleed into

the color before it. Continue adding each of the colors with a clean brush loaded with water, letting them naturally blend together. Work through the techniques noted. This is a good time to notice how the amount of water or the degree it has dried affects things when you apply the techniques. Consider each color and how it is more or less effective compared to other colors as well.

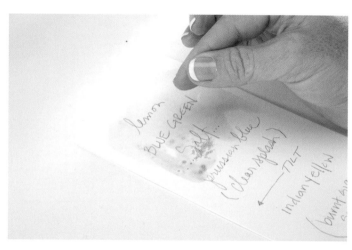

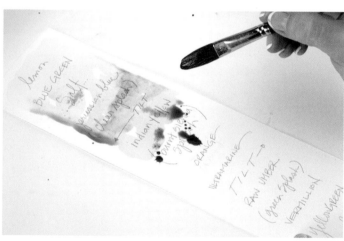

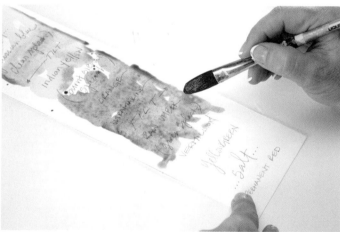

RANDOM THOUGHTS

If you thought that was fun, try rummaging through your art studio, kitchen and even bathroom to see what might make interesting patterns when applied to your washes. Pull out other types of paints, crayons, pastels and pens to create test strips that are all about combining watercolors with different mediums. And don't let all that beauty you've created go to waste! Cover them with clear packing tape, punch a hole in the top and make a test strip key ring. You can even add a strip of fun fabric or a tassel to turn them into one-of-a-kind bookmarks for all of your art reference books!

lemon ↓ great combo!

BLUE GREEN

Salt...

...

prussian blue

(clear splash)

← TILT

PRUSSIAN BLUE + SALT

Indian Yellow

♡←

(burnt sienna splash)

ORANGE

ULTRAMARINE

TILT →o

RAW UMBER ♡

(green splash)

VERMILLION

YELLOW GREEN

Salt...

PERMANENT RED

making mud

For some reason, there seems to be a negative reaction or unnecessary worry about making "mud" when colors mix. We have this unrelenting need to know what the end result is going to be before we start. Hence color charts. Don't get me wrong, I love a good color chart. But I think that in the midst of avoiding "mud," we lose sight of the beauty and the role it plays in making our art shine.

I consider "mud" to be the connecter of all things colorful. When I work through one of my pieces, I always (and I really do mean always) move from one color to the next by mixing a bit of the next color into the color I used previously. It doesn't matter where it is on the color wheel. I keep adding more of the next color a little bit at a time until the latter color is pretty much gone. And the color that results from mixing the two together is often "mud." When the mixture turns brownish or grayish or something in between, it gives me the perfect shade to allow my colors to shine. To stand up and say *hello*!

In this exercise, we will be playing with layers and lots of color to practice working with and embracing the "mud."

MATERIALS LIST

4" × 6" (10cm × 15cm) watercolor paper or scraps

creative supply kit (see page 10)

Dr. Ph. Martin's Hydrus Watercolors

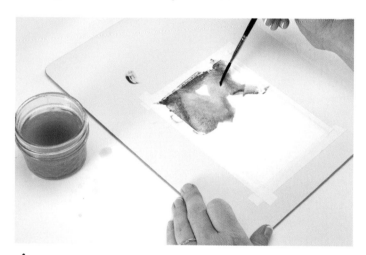

1 Tape and Add the First Color
Using artist tape, tape down a small piece of watercolor paper to your lap-sized whiteboard close to the bottom edge to allow room on the whiteboard to mix your watercolors directly on it.

Add a very small drop of the watercolor paint to your whiteboard. Load your brush with water and paint that color onto the upper third of the watercolor paper.

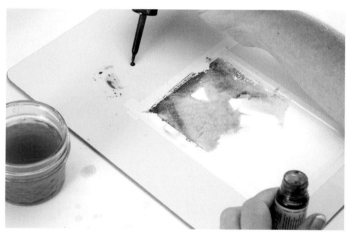

2 Add Another Color
Add another small drop of the second color of hydrus watercolor to the whiteboard.

WHITE PAPER

If you have always worked on canvas, you are probably used to covering every square inch with one sort of medium or another. When working with watercolor, the white paper is your BFF. It is the very thing that makes watercolors so translucent and colorful. Try to always preserve some bits of the white paper here and there. And while you are at it, don't get too carried away with the number of layers you add. The more layers, the less transparency you will have in the end.

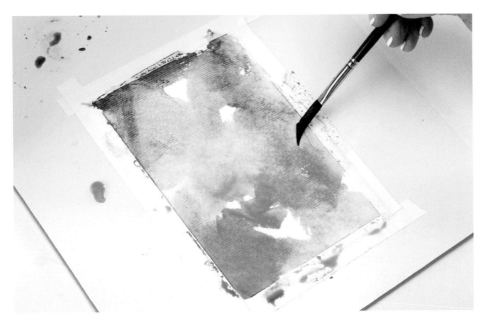

3 Blend the Two Colors
Load your brush with water and color, and paint the lower third of the watercolor paper. This is great practice for transitioning from one color to the next. Let dry completely.

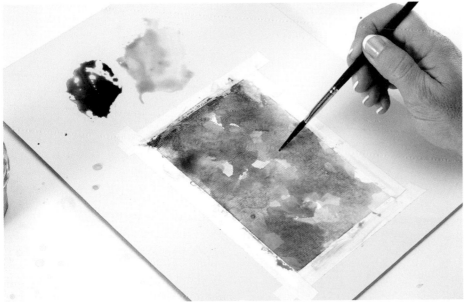

4 Make Mud
Once dry, add a second layer by repeating the process with two new colors. Again, don't overthink your color choices! This is all about learning what you like and what you don't!

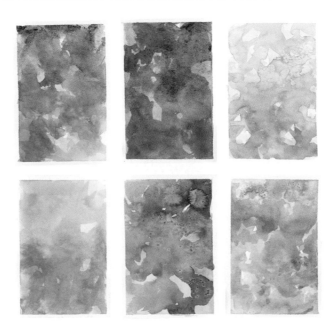

33

making multiple patterns work

If you have a supply stash that looks anything like mine, you have stacks of yummy patterned paper and ephemera just waiting to be used. My drawers are full of so many different patterns: shabby pink harlequins, polka-dots in rainbow rows, earthy green chevrons, vintage postcards and even craft beer coasters. You get the idea. I have been known to spend hours deliberating on the perfect combination of patterns for a handmade birthday card. But when I am working on my mixed-media pieces, I have found that the best way to keep my momentum is to grab and go. And in doing so, I have discovered that the key to success is to mix as many colors and patterns together as possible.

In this exercise, we'll play with patterns overlaid on a pretty watercolor wash. It's a beautiful backdrop and starting point for an illustration. You may even love it so much that you frame it just as it is, and tuck it into a pretty corner of your home!

MATERIALS LIST

- clear liquid adhesive
- craft dryer
- creative supply kit (see page 10)
- patterned paper scraps
- scissors
- shape punch

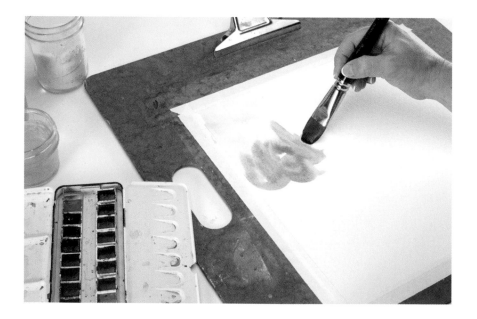

1 Start the Background Wash

Using artist tape, tape down watercolor paper to your oversized artist clipboard. Load your brush with water and start with any color of the rainbow you like. (Use your rainbow reference strip you created earlier in this chapter to remember the order.) Add color to your wet brush and paint a loose wash in various spots on your watercolor paper.

WORK QUICKLY

Make sure that if you're working on a big piece of paper, you're working quickly. The edges can dry fast—so try to keep the edges wet while you are changing colors. If the water dries before you're done, the edges won't blend.

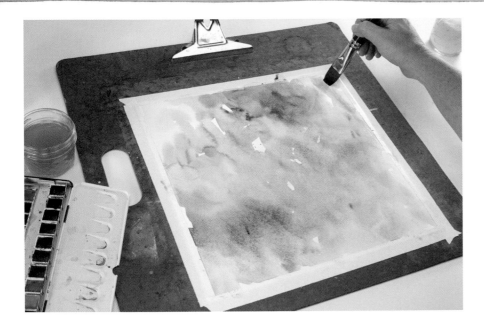

2 Finish the Background

Reload the brush with water and repeat with each color of the rainbow, allowing the colors to blend together until your paper is almost completely covered.

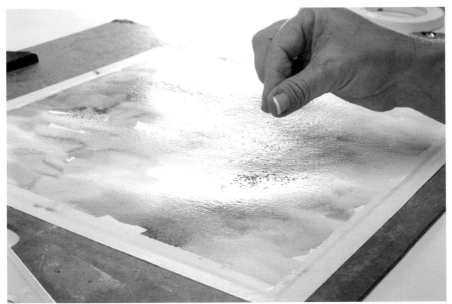

3 Add Salt

Once the whole background is covered, you can put to use some of the techniques you practiced, such as flicking a variety of colors into still-wet washes and sprinkling on salt. Then wait for the magic. That's the fun part! Let the paint dry before brushing off the salt.

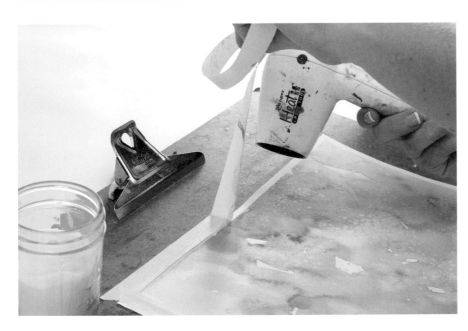

4 Remove the Tape

Sometimes the tape can be hard to pull up and will tear the paper. Use a craft dryer to heat the tape a little as you go. It will be easier to peel off.

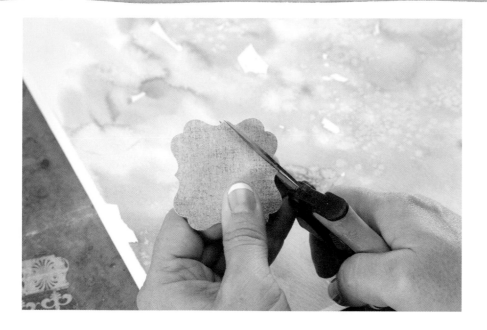

5 Pick Shapes to Collage
Grab a stack of patterned paper shapes to collage onto the watercolor piece. Start with the corner of your piece. Trim the edges of the first shape to fit into the corner.

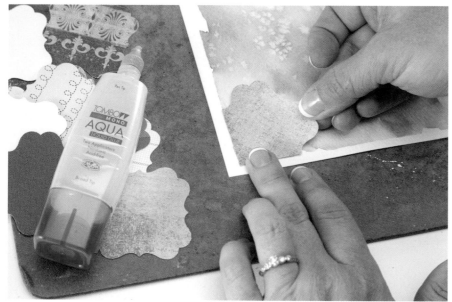

6 Adhere the Shape
Glue down the trimmed shape. The corner is an easy place to build on for the placement of the other shapes.

7 Layer More Shapes
Continue layering on the shapes, covering as much of the paper as you like. If there is a particularly pretty area of the watercolor wash, consider leaving a few spaces open to show it.

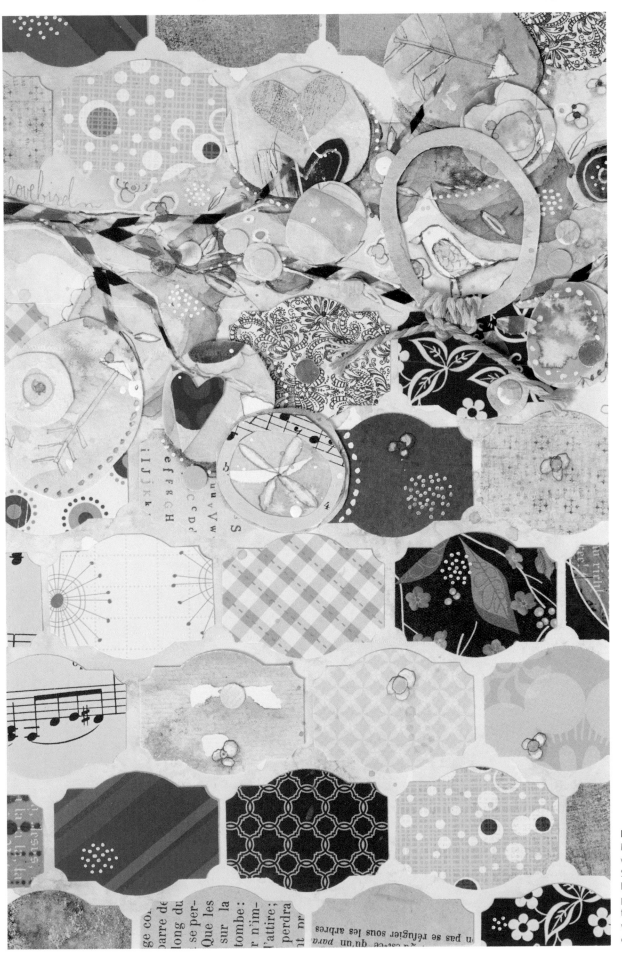

PERCHED
Mixed-media watercolor. Supplies include label-shaped paper punch, washi tape for branches and watercolor paper confetti.

3

*layer*GOODNESS

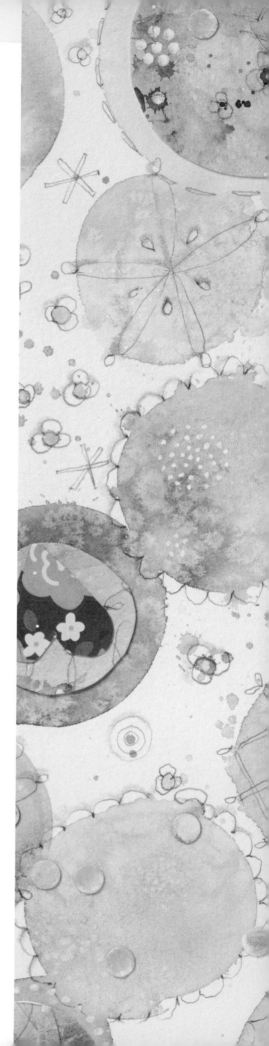

Watercolors are by far my favorite medium. They always have been. But over the last few years, I felt like I needed to explore more. So I worked anything and everything into my pieces: lots of stencils, patterned paper from my scrapbook days and all sorts of acrylics. I loved adding layers and layers of goodness. I worked on big canvases and small panels. I played with color palettes to interpret my mood. I embedded words underneath. I used everything *but* my beloved watercolors. Slowly but surely, I figured out how to infuse them into my art by working with substrates that allowed me to add watercolors over different surfaces in my mixed-media art. I came full circle back to the medium I love most.

Now all of my pieces start with a pencil and watercolors and end with layers of everything else. I am constantly working through mixed-media tools and techniques for other mediums and asking myself, "How can I use watercolors with this?" The result is a brilliantly colorful stash of bits and pieces that I infuse into my mixed-media art. My well-stocked stash can serve as a starting point, a way to work through ugly stuff or the perfect way to add balance or depth to a piece that just doesn't feel finished yet.

The techniques that follow will give you all the inspiration and tools you need to create your very own go-to stash.

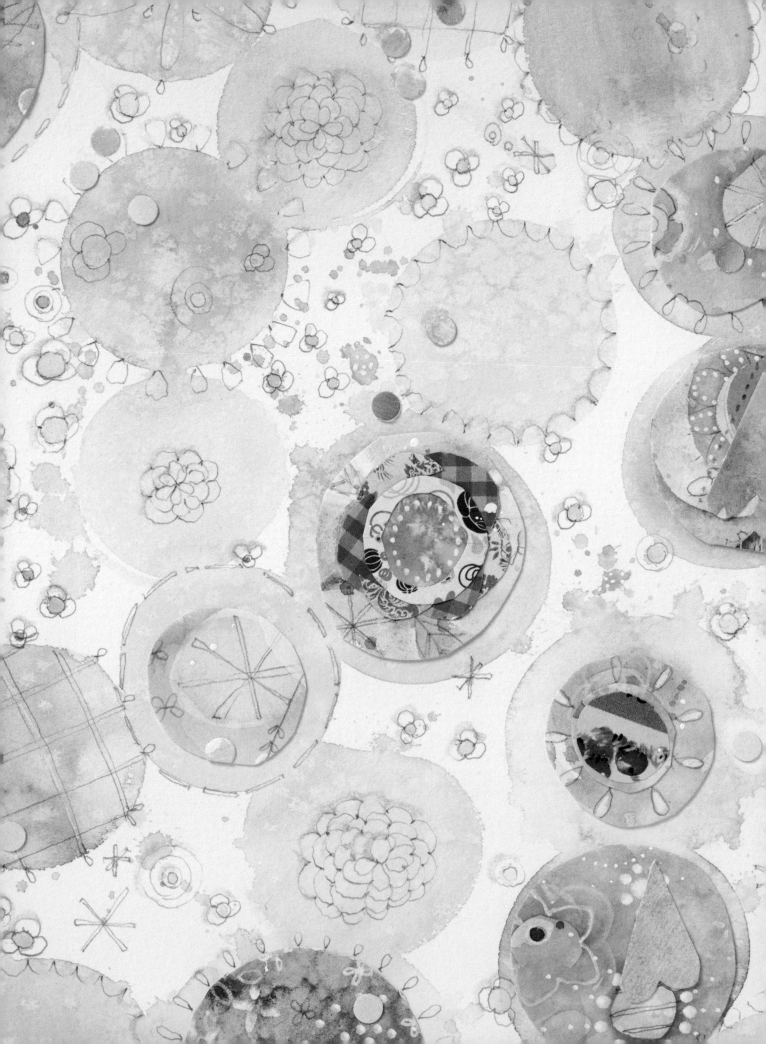

create a watercolor stash

There are times when I feel less than creative. I am tired, or overwhelmed, or cranky or stuck. Painting backgrounds allows me to feel creative and clears my head without pressure. Creating simple but beautiful colors and patterns on paper is a therapeutic way to get out of a slump with the added bonus of a multitude of starting points for future work.

MATERIALS LIST

clear gesso/liquid matte varnish mixture (equal parts)

container of clean water

creative supply kit (see page 10)

hole punch

key rings

Mod Podge

patterned paper scraps or cardstock

ruler

scissors

WET INTO DRY

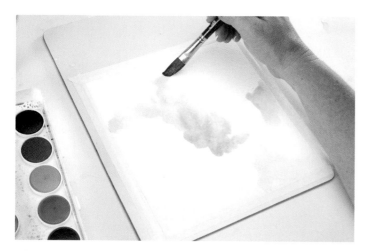

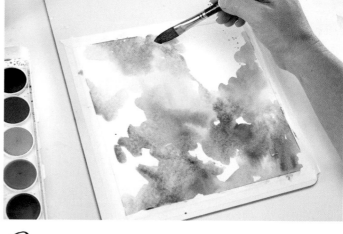

1 Start Adding Color
Using artist tape, tape down watercolor paper to your lap-sized whiteboard or your oversized clipboard, based on the paper size you are working with. Spray your pan watercolors with water, allowing you to pull color from the palette easier. Load your brush with water and your color choice, and begin adding a loose wash to the paper.

2 Continue Adding Color
Apply additional colors in the same manner. Keep adding and blending the colors, covering the background.

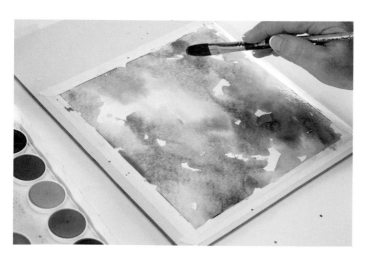

3 Add Splashes and Salt
While the wash is in various stages of drying, add different techniques, such as flicking clear and colored water, pulling up color and adding salt. Do not add color or water over areas where you have sprinkled salt. The salt will not pull color as intended. For that reason, I usually add salt last.

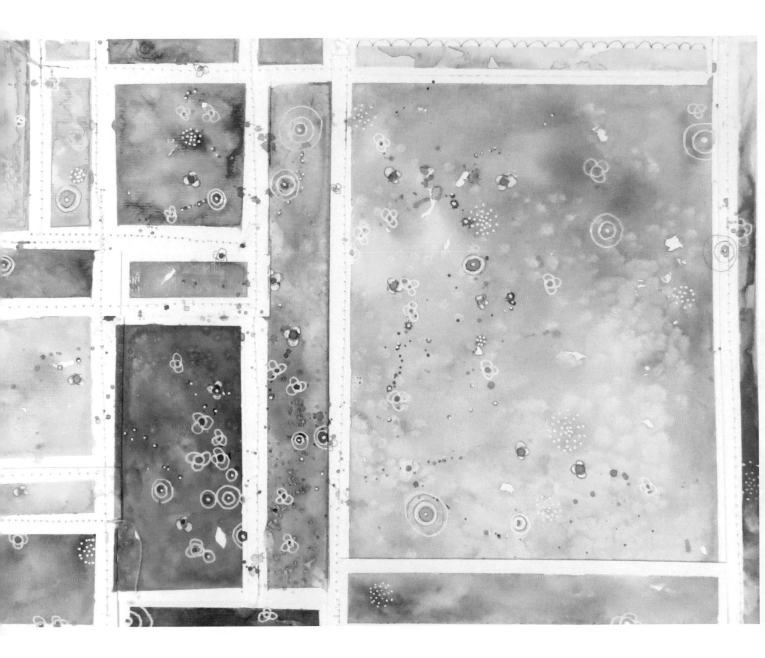

TRY DIFFERENT COMBINATIONS!

There are *so* many different papers and watercolors to choose from. Each paper reacts differently to various watercolors, and there is magic in experimenting in all sorts of combinations to see what you love most. This example is a great way to test combinations! First, sew together different squares and rectangles of watercolor papers Next, tape off different squares and paint different types of watercolors. Finish by adding some fun pencil and white marker doodles.

Pencil in notes about what paper and watercolors you are using as you go. It will create a pretty and functional finished piece!

MONOCHROMATIC AND LIMITED PALETTE SCRAPS

1 Start Painting Scraps

This exercise is a good way to use up your paper scraps. They can be used in future pieces or as a way to practice washes and blending using a limited number of colors. Just add water and color to your brush and paint on the paper. I leave a white border around mine, but you can take your color all the way to the edge if you like.

2 Finish Painting and Add Salt

Continue adding color to each piece of watercolor paper. Feel free to add techniques like splashes of water and salt. Let dry. Brush off any salt.

3 Punch a Hole on the Scraps

Punch a hole in the top and put them together on key rings in color groups, multicolored scraps and patterns. I encourage you to add notes about the color mixes or quotes to the backs of the scraps to make you smile or give you a creative spark. It's always nice to find inspiration for a future creative piece!

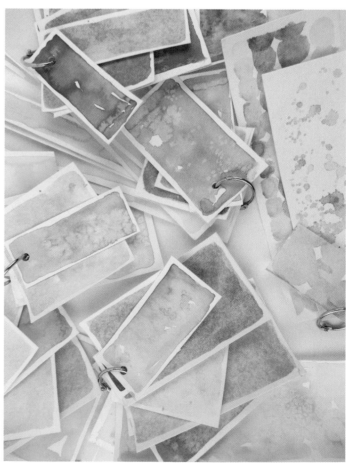

PENCIL AND RULER BACKGROUNDS

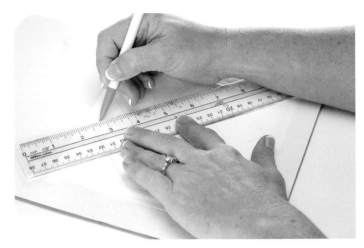

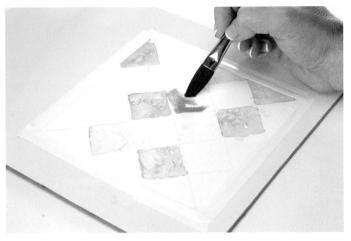

1 Sketch the Background Lines
Using artist tape, tape down watercolor paper to your lap-sized whiteboard or your oversized clipboard based on the paper size you are working with. With a ruler, lightly sketch in the lines for your pattern.

2 Start Adding Color
Load your brush with a moderate amount of water and color. Paint one to three squares. Repeat with different colors until all the squares have color. Don't feel like you have to thoroughly clean your brush every time. While I try to contain the colors to the individual squares, it's pretty cool when they merge together every once in a while. Watch the colors pool together and make an unexpected addition of "mud."

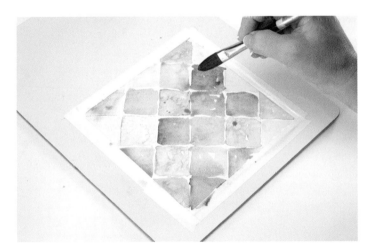

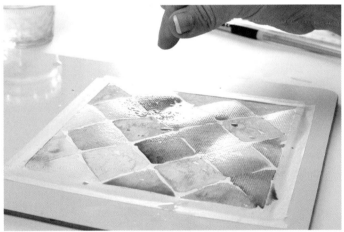

3 Continue Adding Color
Continue coloring in the squares. Load color onto the brush and flick it over the piece to add random splashes of color.

4 Add Salt
While the paint is still wet, sprinkle salt in a few areas. Once the piece is dry, carefully brush off the salt and remove the tape.

CREATING AND USING A STENCIL

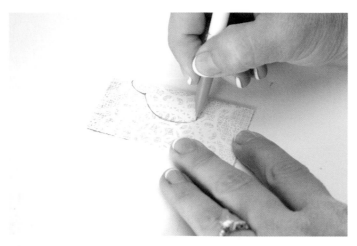

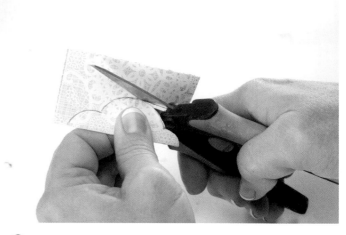

1 Sketch the Stencil Shape
Fold a small paper scrap in half. Draw your shape on one side.

2 Cut the Stencil
Carefully cut out the shape to use as your stencil. You can use the negative and positive of the stencil.

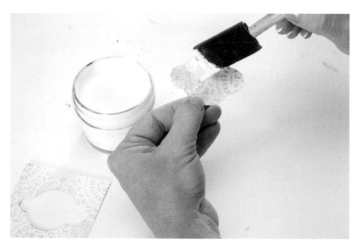

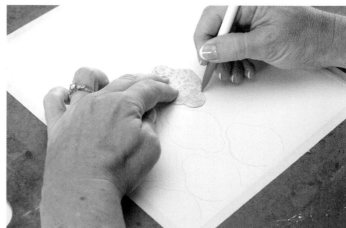

3 Seal the Stencil
Using a foam brush, cover both sides of the stencil with Mod Podge to seal the paper and protect it from the watercolor. Cover the edges of the paper as well to ensure that it is waterproof.

4 Trace Around the Stencil
Using artist tape, tape down watercolor paper to your lap-sized whiteboard or your oversized clipboard based on the paper size you are working with. Using a mechanical pencil, lightly trace your shape onto your paper. Repeat until you have filled in the entire sheet.

WATERCOLOR WARPING

Watercolor paper has a tendency to curl or warp. You can treat the paper beforehand to prevent it but I have found that it is just as easy to flatten the art after I have completed it.

Place your dry artwork with the back of the piece facing up on a clean, flat surface. Carefully spray the back with a light coat of water. You don't want water to overspray and slip under the edges on your finished piece! Weigh it down with a heavy object like a dictionary or baking dish, and let it dry overnight.

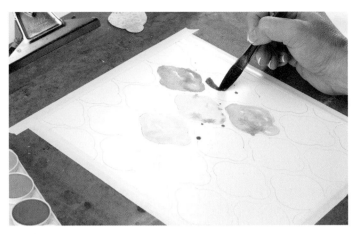

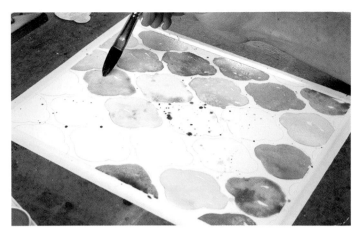

5 Start Adding Color

Add color to the shapes, leaving the space in between white. Adding color in rainbow order will help you achieve a nice set of harmonizing colors and a good balance for the piece. Again, don't feel like you have to thoroughly clean your brush every time. It's OK to leave some color that will bleed into the next one.

6 Continue Adding Color and Details

Continue working around the piece and filling in the shapes. Since this piece is a little bigger, you can splash color and clear water, and sprinkle salt as you go. Otherwise the paint may dry too much while you wait. Let dry completely (you can always use a craft dryer to speed up the process), then brush off salt and remove tape.

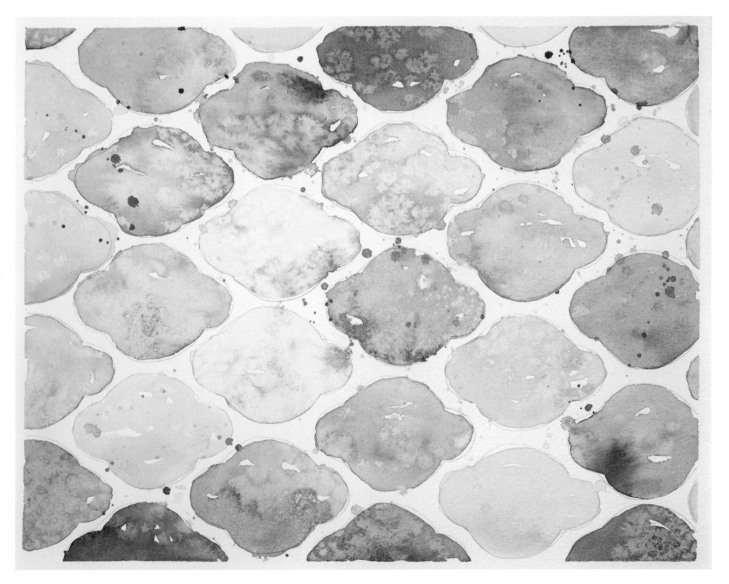

create a layering stash

It's time to turn on your imagination. Dig into your closets and drawers and see what else you can add watercolors to. You goal is to create a stash of dimensional supplies you can layer onto your next color-filled piece of art. You never know what will work and what won't, but a stash allows you to experiment and make some brilliant discoveries. This is where leftovers and ephemera meet up with watercolor awesomeness!

OLD STORYBOOK PAGE

MATERIALS LIST

- birch panel
- clear gesso/liquid matte varnish mixture (equal parts)
- craft dryer (optional)
- creative supply kit (see page 10)
- Dr. Ph. Martin's Hydrus Watercolors
- fabric and lace scraps
- foam brush
- hole punch
- old sheet music or children's book pages
- sewing machine
- white coffee filters

1 Create a Gesso Foundation
Old sheet music and children's book pages are often delicate. To ensure the integrity of the page you have chosen, brush a very thin coat of clear gesso on one side. Let dry completely or use a craft dryer to speed up the process, then turn over and paint the other side. If you use the craft dryer, allow the paper to cool down and dry completely before moving to the next step. It should feel like very fine sandpaper once it is dry.

2 Add Watercolor
Load a moderate amount of water and paint onto your brush, and add a light wash to the page. Cover up as much or as little as you want. Keep in mind though, that the gesso will break down if you add too much water. It is a delicate balance, I know, and you will get better about how much water to add each time you work through the process. Don't forget that you can add salt or paint patterns like polka dots! Let dry completely.

BIRCH PANELS

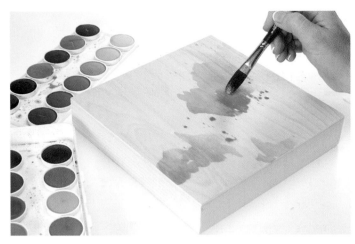

1 Start Adding Watercolor
Add watercolors directly to a birch panel. Notice how the paint soaks in and spreads out in the grain of the wood.

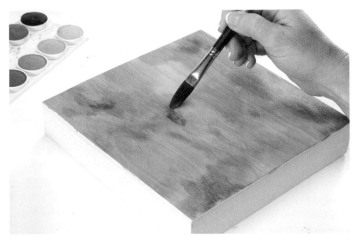

2 Paint the Whole Panel
Continue to add color, and cover the whole top of the birch panel. Be sure to work quickly, keeping the edges wet while adding more colors. Let dry completely.

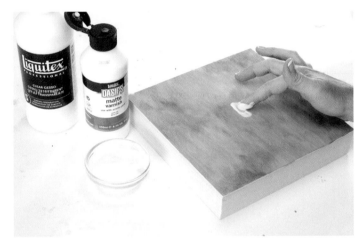

3 Seal the Watercolor
Add a very thin layer of even parts clear gesso and matte varnish mixture with a foam brush or your finger following the grain of the wood. Your finger provides you much more control than a brush, allowing you to spread the thinnest layer possible and feel the spots you may have missed. Let dry.

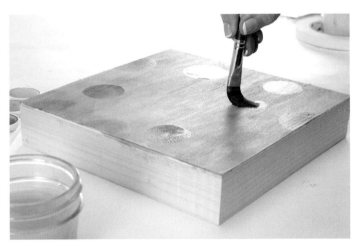

4 Add Details on Top
Once the gesso layer has dried, add more watercolor on top, painting circles of various sizes.

LAYERING COLOR

When I want to preserve a watercolor layer on a panel or add a layer of pencil work, I mix even parts matte varnish and clear gesso and brush a very thin layer over the surface. Varnish seals the layer you already applied while gesso creates the layer that will let you add more color on top. It also gives the surface the tooth necessary to pencil on visual tension and extra details!

It's important to remember that we are trying to seal a water-based layer and that doing so isn't a perfect science. Color and pencil work may move around a bit.

Once you have applied this mixture, allow it to dry thoroughly. It will feel like very fine sandpaper. When you paint another layer of watercolor over the mixture, don't use too much water or the gesso will break down.

COFFEE FILTERS, LACE AND FABRIC

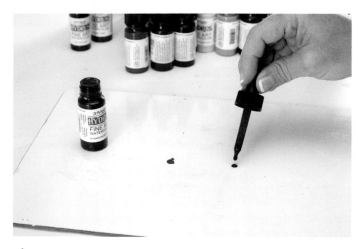

1 Drop Color onto the Whiteboard
Choose two Hydrus colors. Add a small drop of each Hydrus color about 2 inches (5cm) apart onto the center of the whiteboard. These paints are very concentrated so no need to overdo!

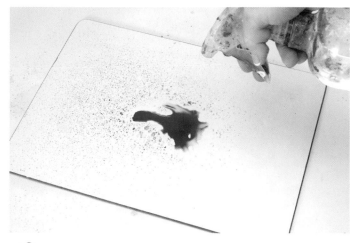

2 Spread the Color With Water
Using your spray bottle of clear water, spray water directly down onto the board to spread the color.

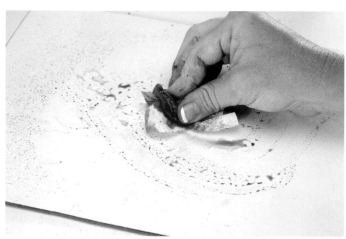

3 Pick up the Color With a Coffee Filter
Lay the coffee filter over the watercolor and wipe up the color with it. You can crumple the filter as you're wiping off the color to add more variety and to spread out the color.

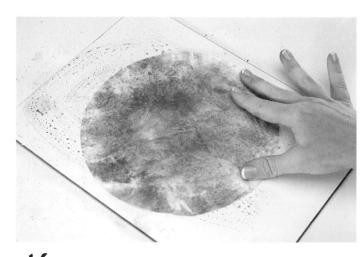

4 Let the Filter Dry
Open up the filter to see how the color spread. Place the filter onto a protected or disposable surface to dry as the color may bleed onto whatever is below it.

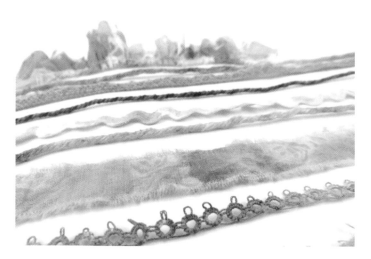

5 Repeat With Other Colors and Fabric
Repeat the same process with different color combinations and more coffee filters as well as a variety of lace and fabric scraps. Experiment and play with different materials.

CONFETTI

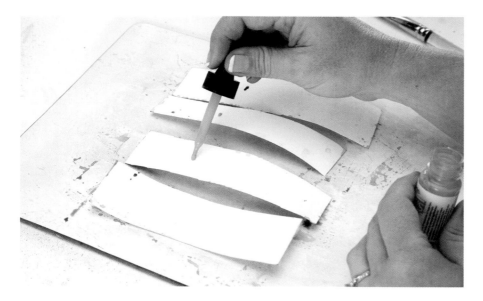

1 Drop Color Onto Scraps
Using Hydrus paints or pan watercolors and your whiteboard, paint scrap pieces of watercolor paper, or select some of the technique tests you made earlier.

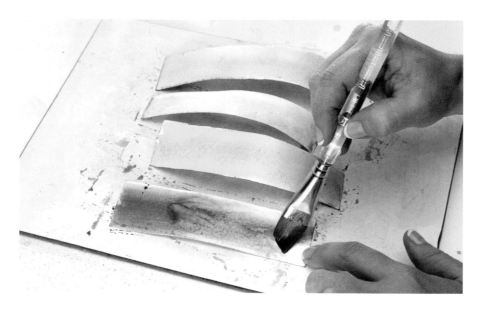

2 Spread the Color
Let one side dry, then turn the strip over and add another color. Don't worry about colors too much. Have fun and use whatever you want.

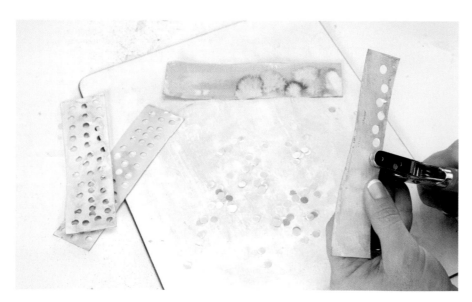

3 Punch out Confetti
Once dry, use a hole punch to punch your confetti from the strips. You can gather up the confetti and store it in a little jar for future projects.

STITCHED PAPER

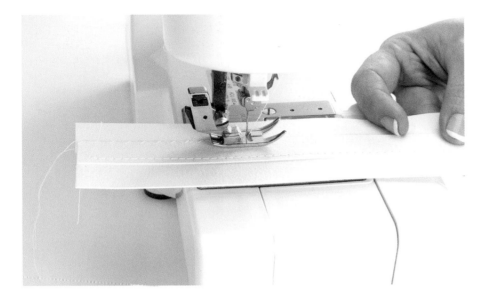

1 Start Sewing the Strips
Cut strips of watercolor paper. Using a variety of stitches, start sewing the strips together.

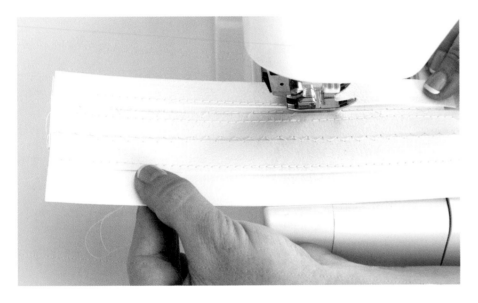

2 Finish Sewing the Strips
Continue sewing strips together until you're satisfied with the overall size.

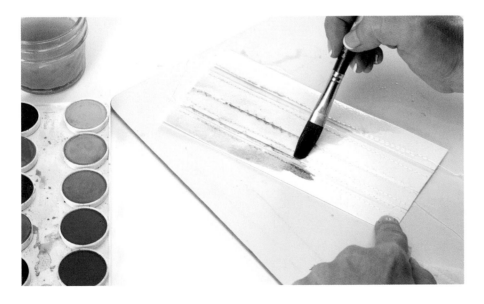

3 Add Color
Add layers of watercolor over the stitched paper. The stitching will absorb color as well.

working with white

Although white really isn't a color—it's the absence of color—it is the proverbial glue that binds my process and creative work together. Recognizing and protecting white space gives my illustrations power and reminds me that I don't have to fill up every corner of my art or my world with "stuff." When I add white back into my pieces, I am intentionally subtracting color and thereby creating some pretty amazing POP! White is an integral part of my process and is often one of the last steps in completing my work, too.

MATERIALS LIST

birch panel

clear gesso/liquid matte varnish mixture (equal parts)

creative supply kit (see page 10)

WHITE DOODLES ON BIRCH PANEL

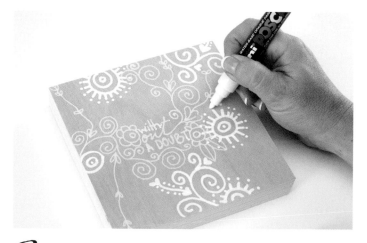

1 Seal the Birch Panel
To prevent the ink from bleeding, prep the panel by painting a thin layer of even parts clear gesso and matte varnish mixture with a foam brush or your finger following the grain of the wood. Let dry completely.

2 Add the Words
Using a white marker, write your chosen phrase or word onto the birch panel. Remember, it doesn't need to make sense to anyone but you, and it will be hidden when you create a project over it. It can be a single word, part of a quote or even someone's name.

3 Start Doodling
Using white markers, add doodles like little clovers, swirls and bull's-eyes to your background. I use a couple of different sizes and tips to create variety and balance.

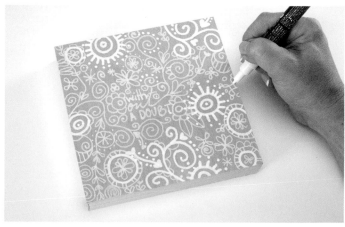

4 Finish Doodling
Continue adding doodles to the panel. Be sure to draw your doodles so they bleed off the edges. You want it to look like they continue off the panel. I love sitting on my couch and working on these to add to my stash. They are quite meditative!

OUTLINING WITH WHITE

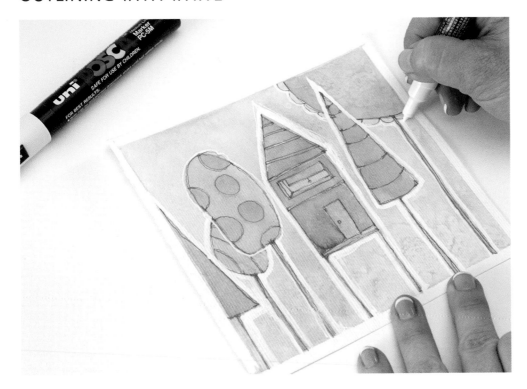

Outlining
Make objects in your paintings pop by outlining them in white ink of various widths.

DOODLING WITH WHITE ON DARK AREAS

Doodles
Add dimension and detail by doodling with a white paint marker in dark areas of a painting.

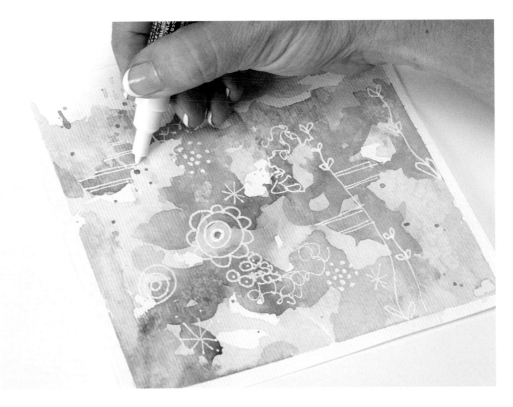

adding light and depth

Adding depth to my art is one of my favorite parts of the process. With watercolors, you can create depth by adding shadows or by preserving white space. Both concepts are tricky to grasp and take a serious amount of practice to master. I suggest making a technique folder that helps you focus and practice adding depth. Just draw simple objects and use one or a combination of the following techniques as a starting point.

Additionally, you can use a small clock illustration that is set at five o'clock as a reference when adding shadows to your work. Your lightest areas will be between eleven and noon and you know what's coming next right? Just remember to create five o'clock shadows. I know it's corny, but it actually serves as an easy-to-remember prompt.

MATERIALS LIST

blending stump

creative supply kit (see page 10)

Derivan liquid pencil

FIVE O'CLOCK SHADOW

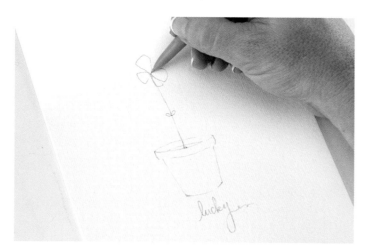

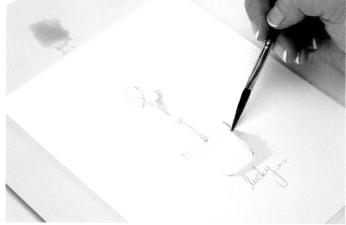

1 Sketch a Simple Shape
Draw a simple shape on a small piece of watercolor paper.

2 Add the First Layer
Using the whiteboard as a palette for your paint, add the first layer of shadow color. As a point of reference, use a simple drawing of a clock. We will always add our shadow at five o'clock. The shadow should be at its widest point at the five o'clock point on the object, thinning out as it wraps around the object. Shadowing is hard, so go easy on yourself. It really takes a ton of practice to learn how to do it right. Just keep drawing various shapes, and remember that simplifying your drawings and making them smaller makes it a lot easier to practice shadowing!

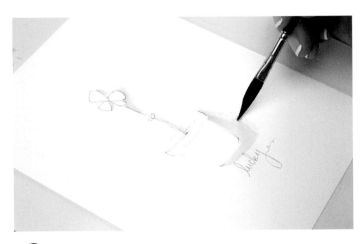 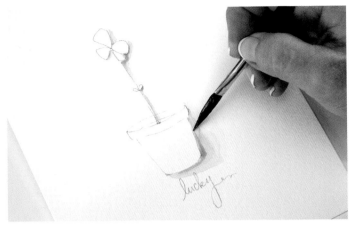

3 Continue Adding Layers of Shadow

Once the first layer has dried, add a second layer of shadow but only cover about half the width at five o'clock and paint closer to the object. Let dry.

4 Finish Adding Shadow

Continue adding layers of shadow closer to the object until you have a very thin line right next to it. As you gain confidence, you can practice on more intricate drawings.

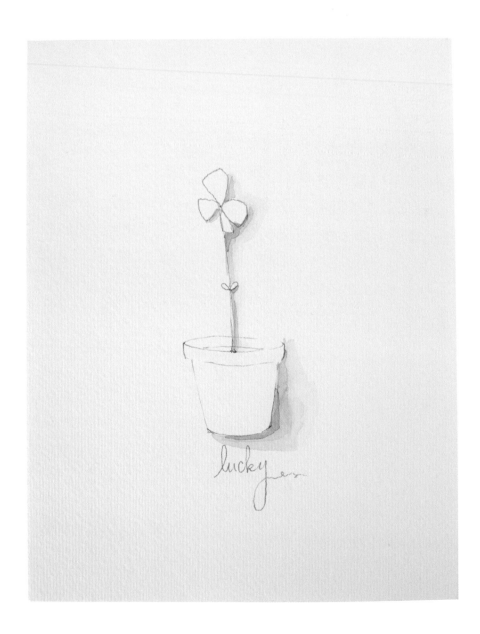

SAVING WHITE SPACE

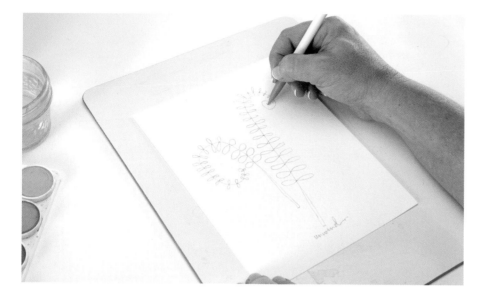

1 Sketch the Shape
Sketch out your shape using a pencil. In this technique, we will be painting around the shape. If you need to simplify the shape to be sure you can paint around it, please do!

2 Add Color
Carefully paint around the shape with a fairly light-colored wash. Alternatively, you could skip the shadowing in step 3 and create a color-filled wash around the shape for a completely different look!

3 Add Shadow
Add shadowing using the method described in the previous technique. Start with the lightest color of your shadow. Once dry, repeat layers of shadows to increase the depth.

Visit CreateMixedMedia.com/creativeGIRL for bonus demonstrations.

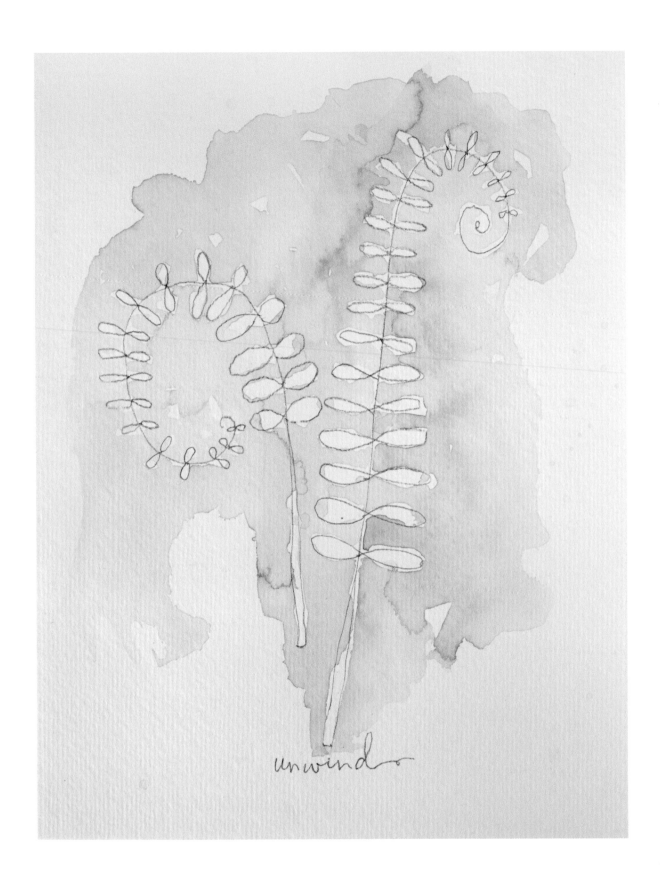

unwind

LIQUID PENCIL

Liquid Pencil Shadow

Shake the bottle of liquid pencil, open it and add a couple drops of clean water to the lid of the bottle to use as a palette. A little goes a long way.

Using the five o'clock shadow technique, add a small amount of liquid pencil to your object. It is rewettable, so feel free to add water to thin it out away from the object, thereby creating more depth.

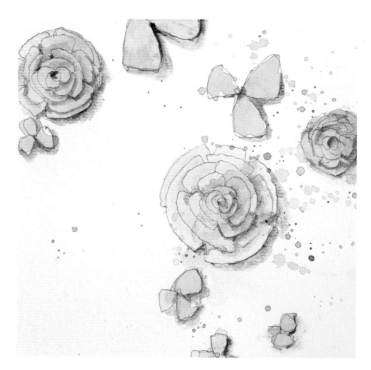

PENCIL AND STUMP

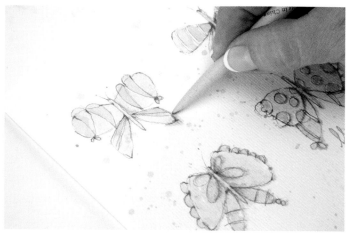

Blending With a Stump

Another way to add shadowing is to work with the pencil lines of an object you have drawn. Use the paper stump to smudge the graphite from the pencil and form a layer of shadow.

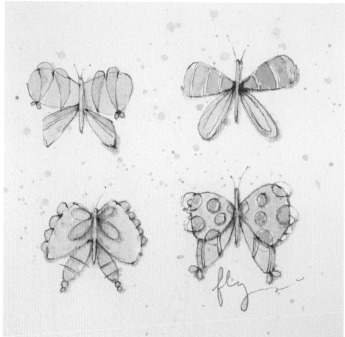

random opportunities to doodle

I try to balance my need to control the outcome in my art and my desire to be carefree and let things happen in surprising and magical ways. It is a delicate process, but a process that has pushed me to come up with creative solutions that make my work mine. It's that "signature look" that ties all of my pieces together.

To begin with, flicking and splashing paint in between color transitions was just something I did. Mostly because it was fun to do. And partly because I knew it was a great way to tie my color palette together. Those little dots and splashes of color were my way of letting go of control in the midst of careful planning. Over time, I found myself using the dots and splashes as random opportunities to doodle. These little penciled-in details have become my last step in my creative process, signaling that I am happy with the piece and it is mine.

These signature solutions evolve over time and sometimes they are there, and you don't even know it. What do yours look like? And if you don't feel like you have any, gather up a few of your pieces and study them. You may be closer to your signature look than you think!

- Is a specific color always included in your palette?
- When you paint girls, do they always have flowers in their hair?
- Do you use brown pencils and pens instead of black?
- Do you create symmetrical drawings even when everyone else doesn't?
- Do you hand-letter a quote for all of your paintings?

If you don't feel like you have a signature look yet, don't despair! It just means that you are still growing into your own creative style. Start paying attention to what parts of your process are innate and which are borrowed from those creative souls you love. Then ask yourself, how can I make this mine in a big or maybe little way?

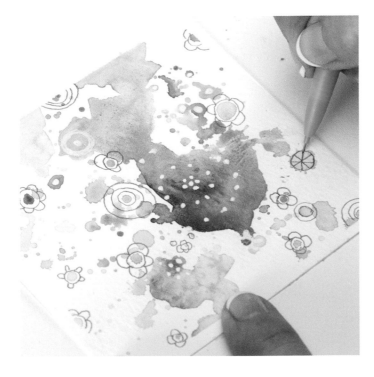

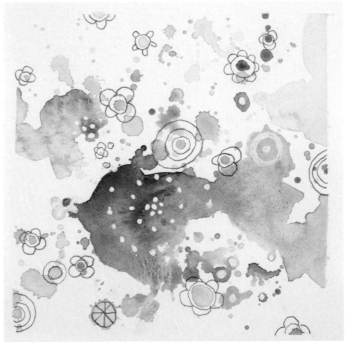

silentTYPE

I am a storyteller. I love to tell my stories with pictures—the kind of pictures that you have to stare at for a long time, the kind that you might never find without me pointing you in the right direction. They are there, embedded in the layers of my art. I hide the words in nooks and crannies, and cover them with layers and layers of questions and sometimes answers. I sprinkle them with secrets, hopes and fears nestled in the shadows and highlights.

Tucking stories into your art is so satisfying. Like a secret you've told to your best friend. Like singing at the top of your lungs in your car until someone pulls up next to you. Like remembering the combination to your high school locker—thirty years later. Like the smell of cinnamon toast that your grandma made for you.

Like that. Exactly.

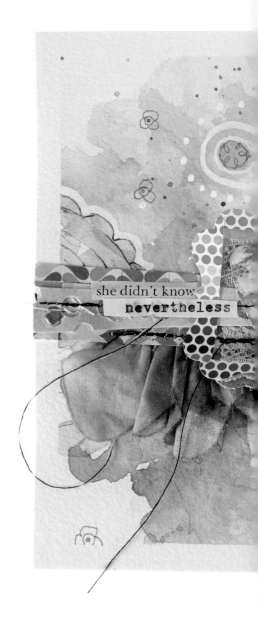

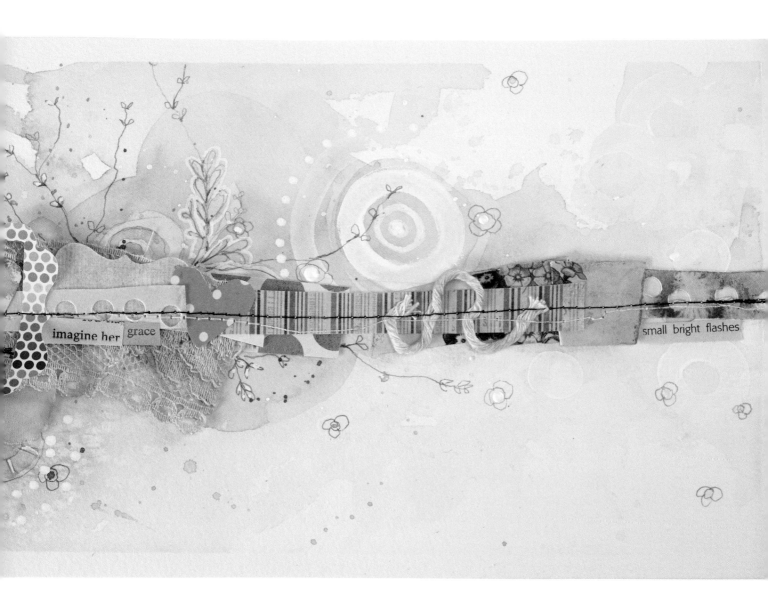

imagine her grace

small bright flashes

hidden messages

I am a homebody. I love the comfort and security of being surrounded by the people and the things I love most. I love the idea of gathering all of my friends, lining up pretty little houses and becoming our own little homebody community. Imagine little illustrated villages filled with scalloped rooftops, rainbow-hued walls, window boxes full of flowers that never need weeding or watering.

Let your imagination run wild! What would your imaginary house look like?

MATERIALS LIST

acrylic glazing medium

birch panel

clear gesso/liquid matte varnish mixture (equal parts)

craft brush

creative supply kit (see page 10)

fluid acrylic paint (Titanium White)

small angled acrylic brush

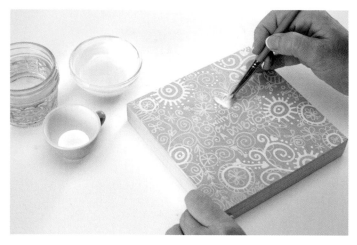

1 Seal the Panel
Using a craft brush, paint a thin layer of clear gesso/matte varnish mixture over the entire white-ink-doodled birch panel (see chapter 3). Remember to use a light touch and to paint with the grain of the wood. This will prevent a significant amount of blurring and movement of the white ink layer.

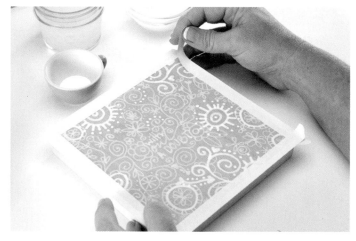

2 Tape Off the Edges
Mask off the outer edges of the doodled panel with artist tape. This will give you a framed look when you remove the tape at the end of the project.

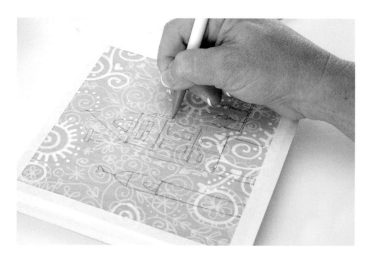

3 Sketch in the House
Lightly draw a tall house on stilts with a deck to the right and a doghouse to the left. Add imaginative details. If you would rather have a row of houses or a church steeple or even a chicken coop, feel free to alter the drawing any way you like. Be sure to wait to add your visual tension until later in the project, after adding the color.

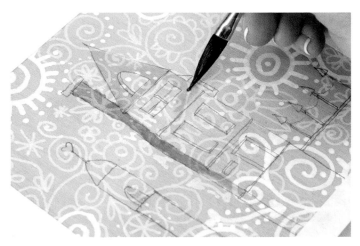

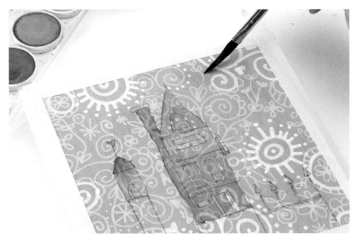

4 Start Adding Color

Add your first layer of watercolors. Don't overload your brush with water. Water will break down the protective layer you added in step 1. Paint different colors in the various boxes and shapes that make up the house as a whole.

5 Add Color to the Background

Paint a small amount of the background with a light wash of blue to indicate sky. Resist the urge to fill in the entire background of the panel with color. Choose the areas based on where you want to create white space. Let dry completely. If you use the craft dryer to speed up the process, remember to allow your panel to cool down before proceeding to the next step.

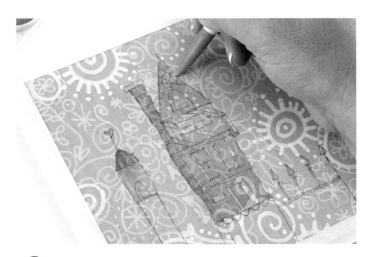

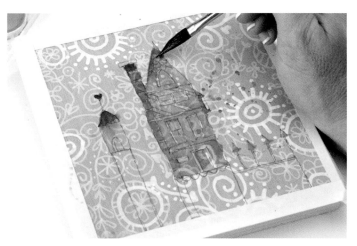

6 Go Back over the Sketch Lines

Using your mechanical pencil, go back over lines that may have been lost while adding color.

7 Continue Adding Color

Add another layer of more intense color, especially in the corners of spaces. This will give the drawing depth. Don't paint the entire area again; you'll lose some of the detail in your pencil work, and it will look flat. Let dry.

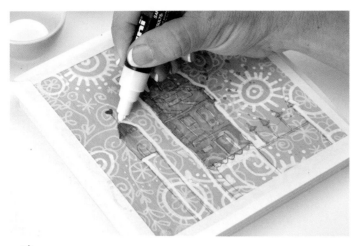

8 Outline the Houses

Using a white paint marker, loosely outline your structures. The size of your marker is dependent on the size of your panel. You'll need a smaller marker if it's a small panel.

9 Add Acrylic

Add white fluid acrylic paint with your finger to various areas of the background. Leave some areas exposed and allow some of the doodles to show through other areas. Add a little glaze to the white fluid paint on the panel and spread it with your finger. The glaze helps to thin out the paint and show the doodles beneath.

10 Spread the Acrylic Paint

Use an angled brush to spread the paint and glaze in tighter areas such as right against the edge of the house. The paint will make the houses pop and allow you the opportunity to pick and choose what doodles can be seen and what will be hidden. Let dry.

11 Draw Final Details

Peel off the tape. Using your mechanical pencil, outline the box that was created by the tape to give it a framed effect. Add a layer of visual tension with your pencil and finish with some little flowers coming up from the ground.

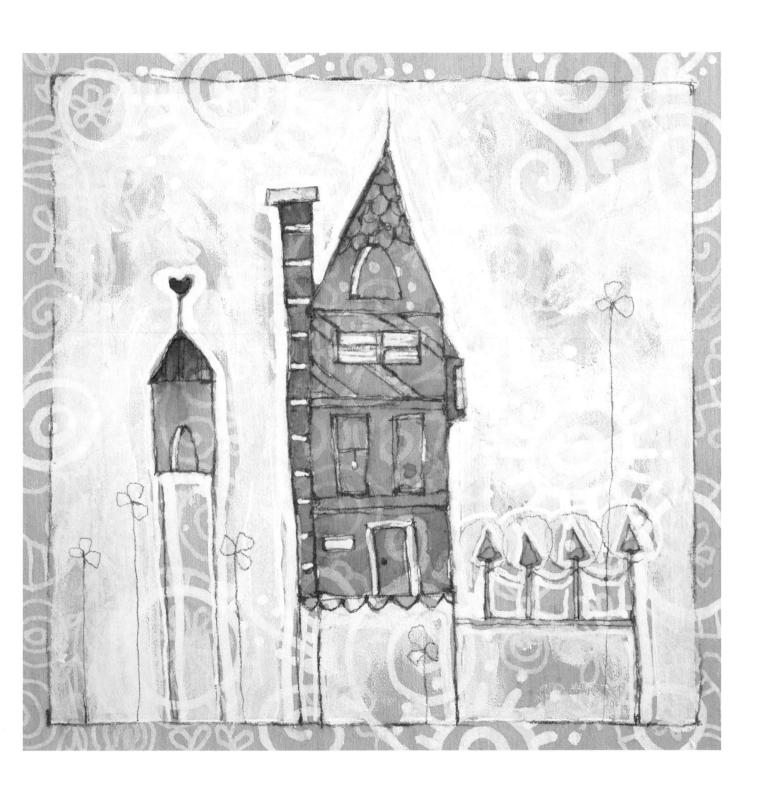

storytelling and word jars

Chairs and couches seem to be a sporadic yet consistent subject matter for me in my art. I love the challenge of drawing and painting chairs in a way that make me feel like I could climb into my art and just rest. My couches often inspire the feeling of wanting someone to sit next to me. Other times they signify my need for solitude or even feeling left out. Often our choice of subject matter is innately a reflection of what we need or want most.

One of my favorite settings for my chairs is imagining them up above the every day and surrounded by all-that-can-be. Could anything be more comfy?

MATERIALS LIST

12" × 12" (30cm × 30cm) watercolor paper

clear craft glue

creative supply kit (see page 10)

glass jar

tray (to spill the words into)

words clipped from books

1 Sketch the Chair Swing
Using artist tape, tape all four sides of the paper to the clipboard, taking care to cover the same amount of paper on each side to create an even border when the tape is removed. Lightly sketch your chair swing first and then your trees. The trunks should be tall and thin with various sizes of treetops as well. Add the ropes that extend from the trees to your swing. Add details to your chair swing, like stripes and pillows. Finally, add banner flags to the rope.

2 Paint the Background
Add a light wash of blue to the background. Be sure to leave white space and to keep your edges wet to continue the wash over a large area. If you have to mix more blue and it doesn't exactly match, that's OK. Just be sure to add the new blue to different spaces on the paper to make it look like a purposeful choice. Let dry.

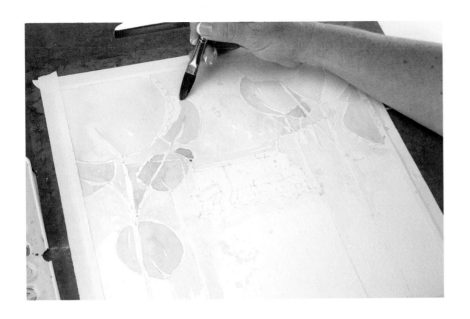

3 Add the First Layer to the Trees

Add the lightest layer of green to the treetops. Be sure to use different variations of green on treetops that touch each other. It will make it easier to differentiate them and give them depth later in the project. Let dry.

4 Add Shadow

Rather than adding highlights to the trees with white ink, we will preserve part of the first wash to serve as our highlights by painting several layers of green, using the five o'clock shadow technique. To give the treetops a ball-like shape, add a wide layer of green in the shape of a crescent moon to the lower right side of the treetop. Don't clean your palette between layers! Create new greens with a mix of whatever greens are on your palette. This is a great opportunity to play with color and tie the trees together using mixes of their original color. Add the crescent moon shape to all of the treetops and let dry.

Once dry, add another layer of green to the crescent moon shape painted in the last step, but only cover half of the area this time. Repeat this process three or four times for each of the treetops using an increasingly darker shade of green. Each layer should be half the size of the last.

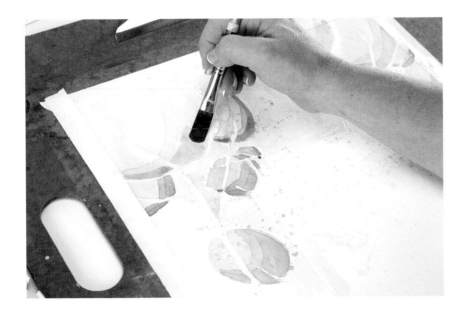

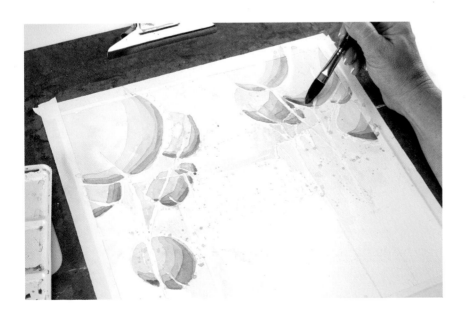

5 Continue Painting Layers of Shadow

Continue adding layers of green to the trees. Your last layer should lean more toward black, brown or Payne's Gray than green. It's OK if the trees aren't all the exact same color. You want some variety. Your final layer should be a thin line that finally defines the shadow of the treetops. Notice that the upper left portions that had the original light green wash now look like highlights.

DON'T CLEAN YOUR PALETTE

It's rare for me to take the time to clean my palette. Especially when I am working through a painting. Leftovers are an awesome way to make your colors automatically go together. Just mix the next color with the last color you used. Add green for the tree to the leftover blue from the sky. Then, when mixing the next green color for the tree, mix that with the previous mixture of color. Doing this pulls the art together. Don't forget to add flicks and splashes of colors while you work through the different areas of the piece.

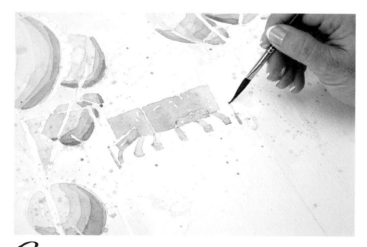

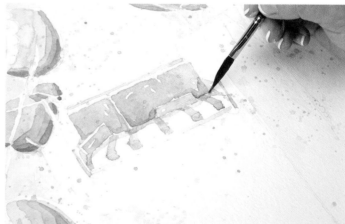

6 Paint the Chair Swing

Using similar techniques from step 5 and a dagger brush, add a light wash of color to the back cushions and the stripes on your seat cushions. Creating depth with color choices and shadows is hard! If you are sitting there with brush in hand, scared to add color, take a break. Maybe take a little time to sketch and paint the swing on a scrap of paper. And when all else fails, copy my color choices and placement. Start with really, really light washes and take your time to think about the next layer for a minute or two.

7 Add Shadow to the Chair

Once your layers of color are in place on the chair swing, start mixing a touch of black, brown or Payne's Gray to the colors you have on your palette and add shadows to where the seat cushions meet the back cushions. You can also add really small shadows to the areas between the cushions and the bench. Don't forget to add color to the wood portion of the swing, the pillows and the banner flags.

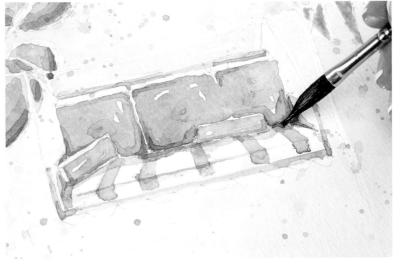

8 Continue Adding Shadow to the Chair

Continue to add more shadows, building up the layers in the same way you made the trees.

9 Add the Shadow Beneath the Chair

Using the five o'clock shadow rule, add a shadow that the swing casts underneath. Mix whatever is left over on your palette and add Payne's Gray to it. Start at the bottom edge of the swing and define the sides of the shadows. Once you have defined the boundaries of the shadow, you can drop more color in and thin it out toward the lower right corner. Notice where the shadow is darker and where it is lighter. The farther away from the object, the lighter the shadow is. Let the shadow dry. Last, add a light shadow wash to the tree trunks. Let dry again.

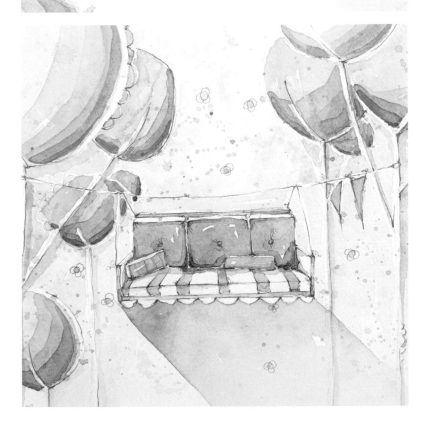

10 Add Visual Tension

Go back over the entire piece with your mechanical pencil and draw over the lines again, varying the line weight for visual tension. Don't forget your random opportunities to doodle!

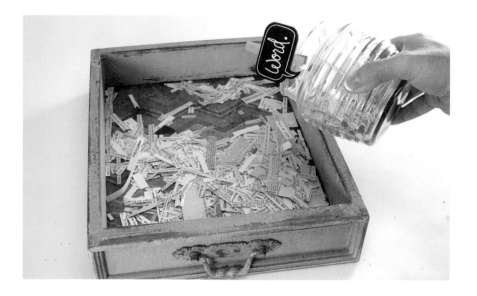

11 Choose Words

Using a box, an old drawer or even a pie tin (something with sides and a smooth surface) spill words out from your word jar. Start building your mini-story by choosing random words. Watch out! This process can be addicting!

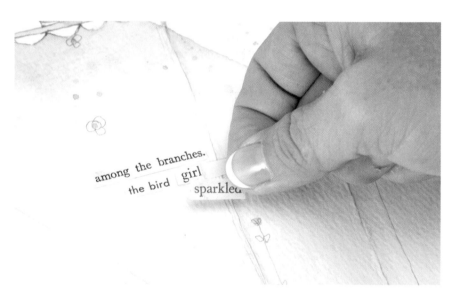

12 Collage the Words

Before adhering your words to your art, place your mini-story in different places on your finished piece to see where it enhances the composition rather than distracting the viewer. I always group my words in an odd number of lines. It's usually more pleasing to the eye. Once you are happy with the placement, glue your words in place.

WORD JAR

Sometimes I start an art piece with a story of my own to tell. Other times, I let the art piece tell me its story. Word jars are a wonderful way to help you choose the words.

Start collecting pages from old dictionaries, children's books and vintage magazines. Cut out words or really short phrases and add them to your word jar. I have found that the shorter the phrase, the better. It allows you to use your imagination a bit more. And don't forget to add words like "was" and "in" as well as pronouns like "she" and "her" and lots of "and" conjunctions. You will need them to connect the descriptive adjectives and verbs together.

Another great way to build your word jar collection is to ask your art friends to dig into their stash and swap. You can just share whole pages or take it up a notch and send an envelope full of already clipped out words. I prefer the latter because I get a peek into my friend's worlds by looking at the words they choose.

I have a decorative tray that I use to spill out the contents of the jar. I just spread the words out and start building a story word by word. It's helpful to see the words like this.

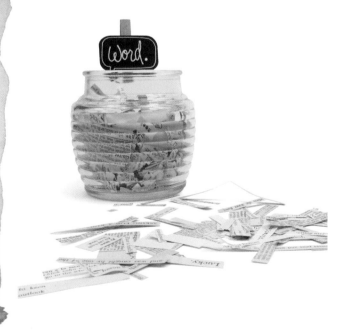

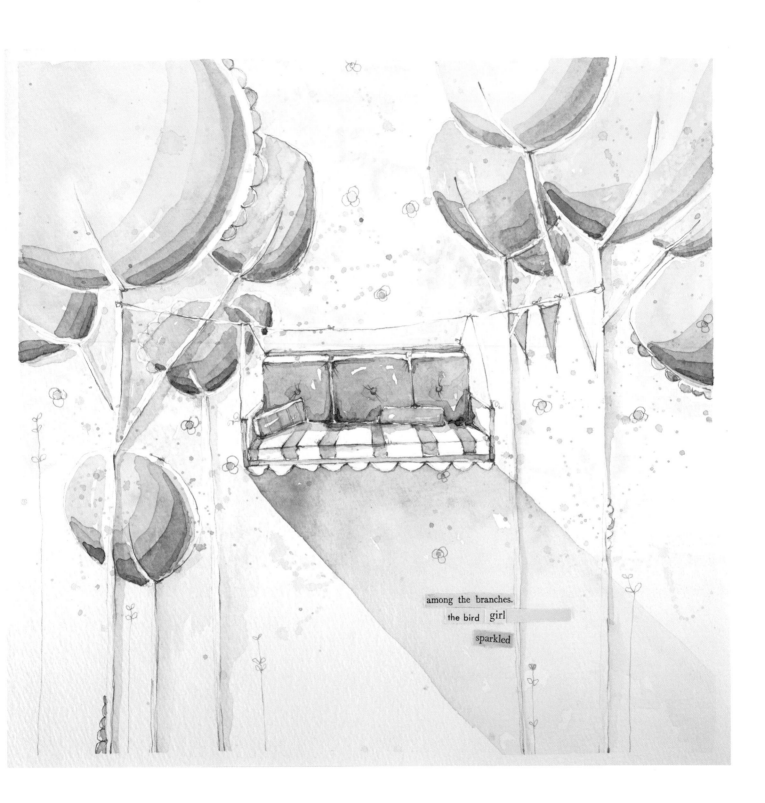

among the branches.
the bird girl
sparkled

creating a visual timeline of you

I am not a foofy girl and can be pretty darn sassy. I have issues with worrying too much. I own my own stuff, my actions and reactions. And I have impossibly high expectations and a pathetically low tolerance for spontaneity. I am loyal and funny, bossy and anal, and pretty darn creative. I love deeply and have been told on more than one occasion that I care too much. I own all of it. And all sorts of stuff got me to the place I am right now.

This project is my way of chronicling the story of me. The good and bad, high and low, out-of-my-hands-most-of-the-time, downright beautiful life I am living.

MATERIALS LIST

6" × 12" (15cm × 30cm) watercolor paper

clear craft glue

creative supply kit (see page 10)

fancy paper punch (optional)

fluid acrylic paint (Titanium White)

lace and fabric scraps

patterned paper scraps

scissors

sewing machine (white and black thread)

watercolor paper scraps

white paint marker

words cut from books

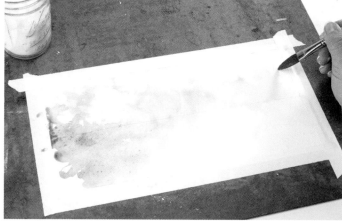

1 Draw the Timeline and Start Adding Color

Tape your watercolor paper to the oversized clipboard. Using a ruler, lightly pencil a line that divides the paper in half lengthwise. Consider this line the timeline of your life. Based on your age, and assuming we will all live to one hundred, mark an X on the timeline where you are now. The bottom portion signifies the times in your life that you have faced adversity, lost loved ones, struggled personally or lost sight of your path. Deep and kind of dark, I know, but they are important parts to acknowledge. The top portion represents joyous events: births, marriages, life-changing gatherings and attaining goals that you have set for yourself.

2 Continue Adding Color

Take a moment to think about what different colors mean to you before you start to add paint. Could your favorite color signify your happiest moments of your life? What does a dark time in your life feel like? Is it a deep brown like mud? Or a dark blue like the nighttime sky? For some, red signifies love and passion, but for others it may be danger and unresolved issues. What colors do you personally associate with the present and past times of your life? What colors do you think of when you think of your future? Once you have correlated colors with events or feelings, add a loose wash of colors to your timeline. Add salt and splashes of color while the wash is still wet. Then let dry.

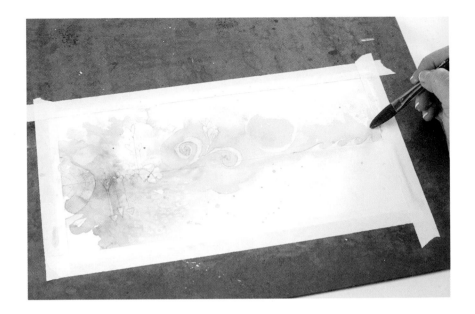

3 Start Developing the Details

When adding the next layer of color, try to think of milestones as shapes like hearts, a bull's-eye and arrows. Sketch a few of these shapes and add another wash of color, allowing the first wash to peek through in places. Paint in or around any symbols or shapes you added. If you feel like you need to add a word or name to your timeline, this is a great time to do it. You will have the opportunity to hide it or highlight it when making additional layers. Just do what feels right to you. Add salt, pull up color with a paper towel, etc. Let dry. Repeat with an additional layer or two if you feel called to do so.

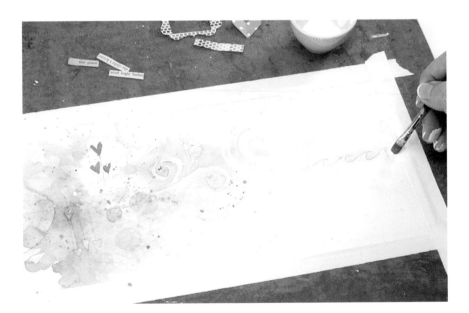

4 Add White

Using a small, angled acrylic brush, add a layer of white fluid acrylic paint. You can cover up areas that you want to keep secret or preserve special spots by circling it with white paint. Again, this process is for and about you and only you. It is your story! Add details with your pencil.

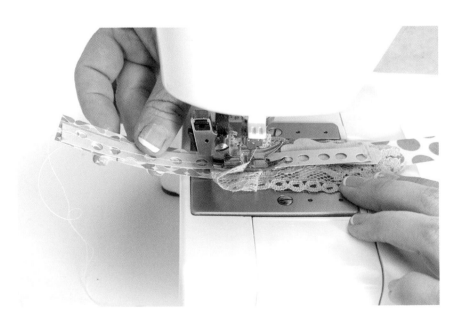

5 Sew Together Scraps

Go through your stash and pull out scraps of fabric, lace and leftover watercolor paper. Assemble and layer them in a line that is pleasing to you. The patterns, colors and textures should be an extension of you and your journey. Once you are happy with your choices and placement, carefully stitch them together with white thread and your sewing machine. Feel free to use different stitches as another way of interpreting your life. If pieces shift or your stitching is wonky, that makes it even better! Life is messy and beautiful all at the same time, right?

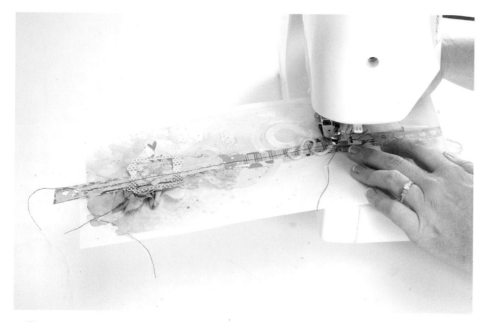

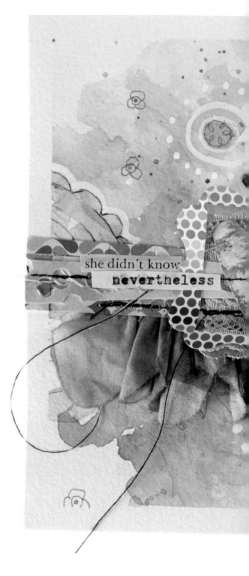

6 Stitch the Scraps and Timeline Together

Lay your assembled and stitched strip over your penciled timeline and sew them together with one line of black thread. The black thread replaces the penciled timeline that you are covering up.

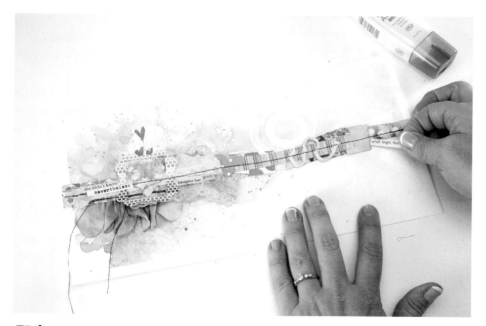

7 Add Words and Final Details

Choose a few words from your word jar and any other embellishments to tuck into your timeline. Once you are happy with your placement, adhere with clear craft glue. Add details with a pencil and white paint marker to complete the project.

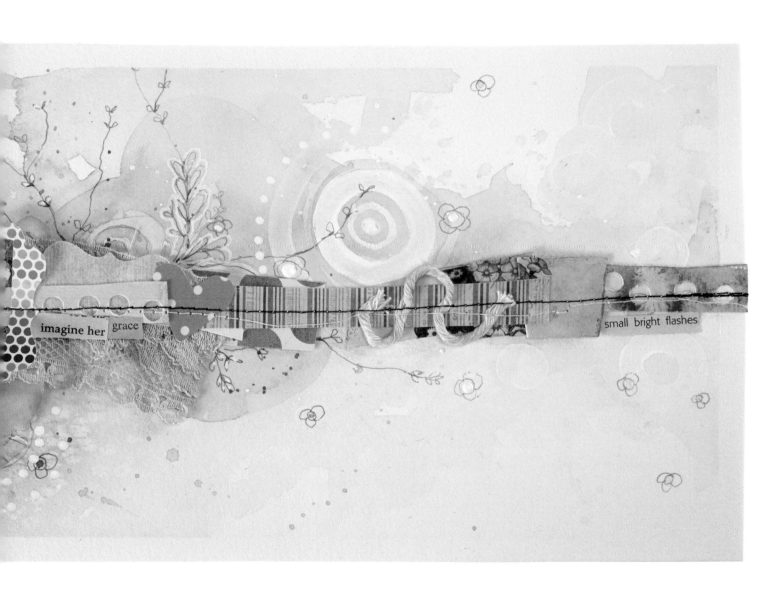

imagine her grace

small bright flashes

creativeGIRL

Over the past few years, I found myself feeling like my "signature style" wasn't complete. I was spending too much time emulating the art that inspired me and not enough time practicing and imagining on my own. I substituted a pencil and eraser for acrylic paint and stencils. I tossed on layers of patterned paper instead of rediscovering the simple power of perspective. I minimized the power of light and shadows, detailed simplicity and my love of white space. While it was pretty darn satisfying, it wasn't 100 percent Danielle. And I knew it. I was hiding in my ability to make things pretty. I was hiding my true self, although I didn't know it at the time. Really I was just mad and sad and lost in a world chock-full of people who were "luckier" and "more talented" than I was.

I decided to set aside canvasses and the need to paint *big* and replaced them with panels and paper that fit on my lap. Then I added layers and layers of goodness that always included my first true love, watercolors. And in the middle of all the layers, I rediscovered my gift to illustrate. Folders full of blank paper were filled with micro-sized sketches of girls' heads and eyes and long, skinny legs. I found myself drawing chairs and couches with comfy throw pillows and balloons tied to the armrests, and lovely little houses in the middle of rainbows. The sea came next. Each series moved me closer to the new version of me on paper.

Complicated simplicity. Detailed transparency. Messy precision. Sassy colorfulness.

I left behind the need to "be seen" and replaced it with the need to share pieces of myself through pictures of my process. And then something amazing happened. Well, two things actually.

I had created my very own "style"—a colorful thread that connects all my work. And when my work was seen, I was being seen, too. So, in the end, the trick is that the more of *you* that you put in your work, the closer you are to having a "signature style." And, really, if you think about it, it is less about your "style" and more about being seen anyway.

While you work through the projects in this chapter, I hope you see little flashes of possibility—rainbow-colored fireworks of what is to come for *you*.

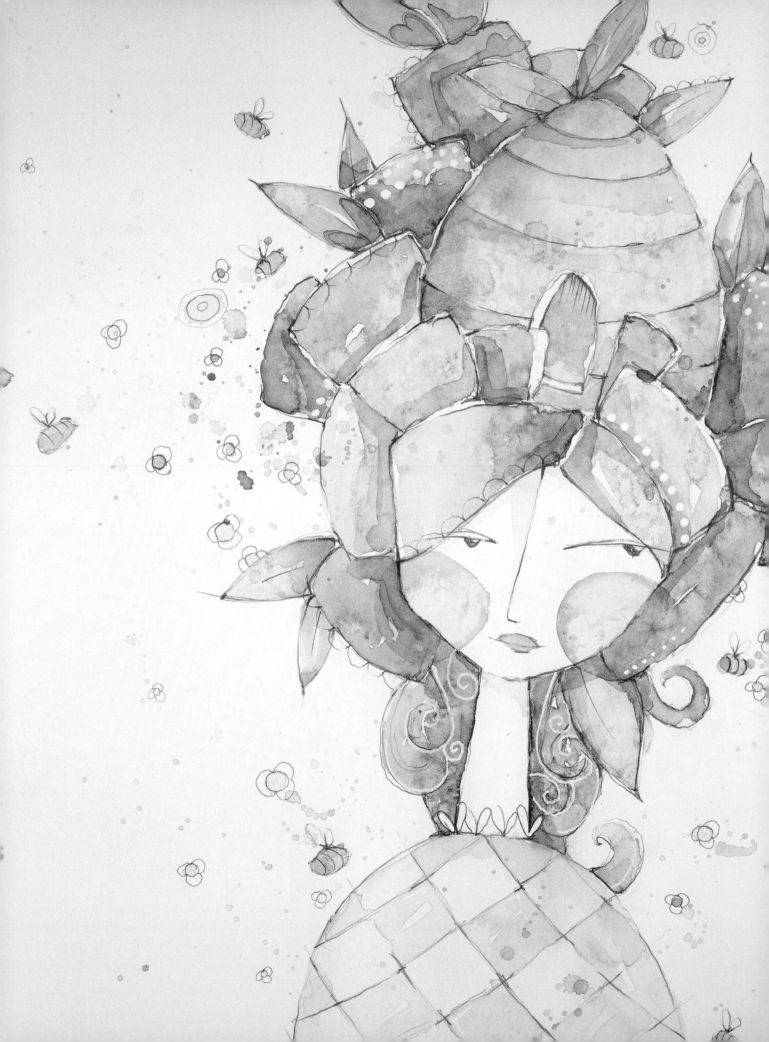

busyGIRL

This girl has a lot on her mind. Literally and figuratively. She tells her story with such beautiful imagery. To one, she may be whispering stories of her love of nature. To another, she may be sighing as she reads her too long list of to-dos. To me, she says, "Danielle, you have no idea how many amazing ideas I have buzzing in my noggin right now. Let's play!" What does she say to you? And if you could choose what to nest in her twisted-up locks, what would it be?

MATERIALS LIST

9" × 12" (23cm × 30cm) watercolor paper

creative supply kit (see page 10)

patterned paper scraps (for figure stencil)

scissors

white paint marker (fine point)

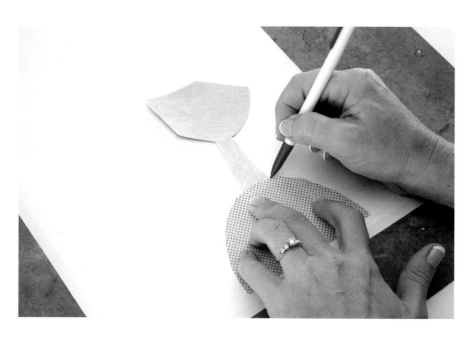

1 Trace the Figure Stencil
Tape your watercolor paper to an oversized clipboard. The clipboard allows you to turn your art while you work, preventing a lot of pencil smudges and accidental smears from the washes. Trace around a handmade busyGIRL stencil with a pencil.

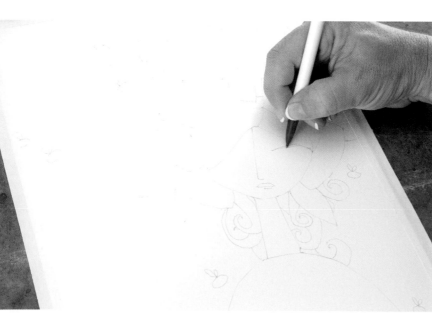

2 Draw the Features and Hair
Draw her facial features, bangs, buns, leaves and the beehive. Add details like the bees and the pattern on her frock.

CREATING A FIGURE STENCIL

It can take a lot of practice to come up with a face and neck shape that you love that fits perfectly on the size of watercolor paper you use most often. You would think that if you could draw it once, you could draw it one hundred times and it would look the same. Totally not the case!

You can use leftover patterned paper to create a stencil for the basic shapes of your girls. Draw the head, neck and body shape on scraps of patterned paper. Then cut them out, position and glue them together. Once the glue is dry, cover both sides and edges with Mod Podge to seal the stencil. Once dry, place the stencil on your watercolor paper and lightly trace it with your pencil. You can then modify it a bit to be sure each girl has her own unique personality.

3 Add Color to the Beehive

Add a wash of yellow and orange to the beehive and bees. Start the yellow wash on the right side and move to the left. Add orange to the yellow on your palette and blend in with the yellow until the right side is orange. This gives the beehive dimension. Add a wash of yellow and green to her frock. When you are happy with the washes, sprinkle a bit of salt on the still-wet areas.

4 Paint the Hair

Carefully add washes to the buns using blues, teals and purples. When the wash from a bun meets a still-wet wash on the hive, the two areas will bleed color into one another. This is a really cool effect, but if you don't like it, wait until the beehive dries before painting the buns. Once you are finished with the buns, paint the leaves pink. Don't forget splashes of color to create random opportunities to doodle and tie your color palette together. Add salt when you are done with the washes. Let dry then brush off the salt.

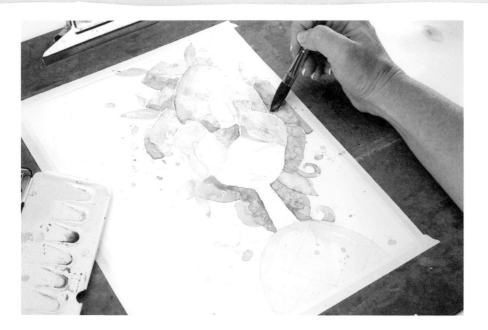

5 Add More Layers of Color

Add a second layer of color on various areas to give more depth. Try to use a similar color to whatever is below it. Remember, the intensity of the colors can make an object recede or pop the same way a shadow can. Pay close attention to your process and choices to see what works and what doesn't. Add salt. Let dry and brush off salt.

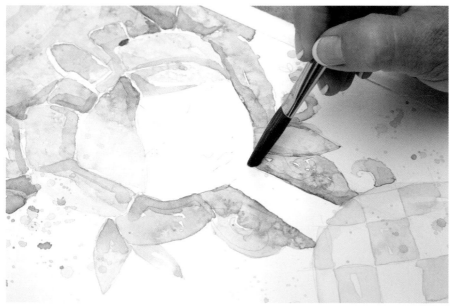

6 Add Shadows

Mix leftover colors on your palette to create "mud." Use the "mud" to add shadows to her neck, buns and beehive. Let dry. You can deepen the look of some of the shadows by adding another layer of "mud" to the first shadow but reducing the width by approximately half. This is the same technique we used in the chair swing project in chapter 4. Let dry, then brush off the salt.

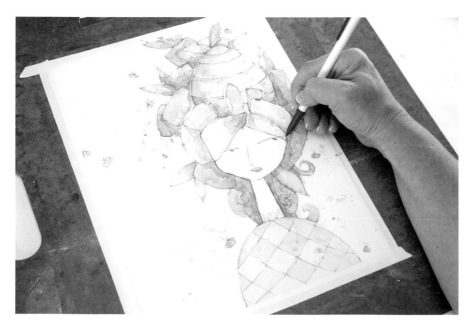

7 Redefine the Shapes

Once the watercolor is dry, go back with a pencil and redefine the shapes, adding visual tension with varying line weight. Be sure to pencil over her eyes, nose and lips again!

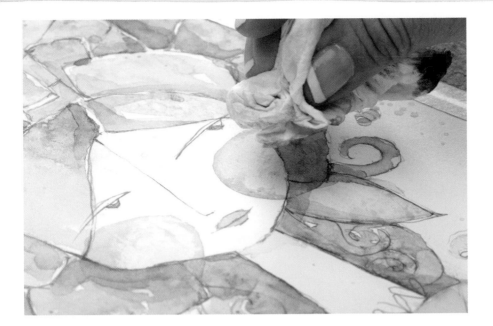

8 Color the Cheeks
Mix a subtle pink color, using the pink from the leaves and just a touch of orange. Add a circle to both sides of her face to create the cheeks. Allow the cheeks to dry a bit, then press a crumpled paper towel into the center to keep the edges darker and make the center lighter. Let dry.

9 Add Final Details
Add little details and doodles using your mechanical pencil and thin white ink pen to finish the project.

PROMPTS FOR BUSYGIRL HAIR DECORATION

Anything could be twisted up in her hair. Try a few of these to change up her look:

- goldfish bowls
- an ant farm
- classic novels
- paper boats
- birthday cake
- birdcages
- starfish
- cocktails
- laundry baskets

- art supplies
- sunshine and clouds
- rainbows
- potted plants
- school supplies
- coffee cups
- sticks and stones
- heart-shaped pillows
- feathers

- kittens and yarn
- musical notes
- houses on stilts
- holiday garland
- tree branches
- ice cream sundaes
- postcards

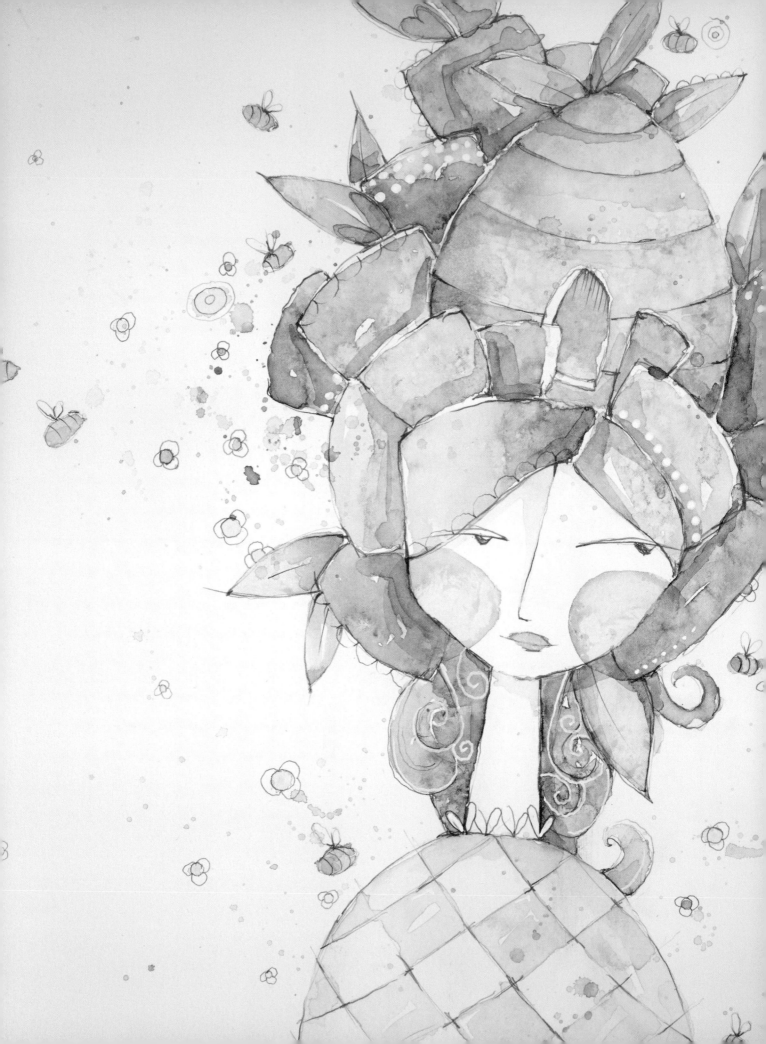

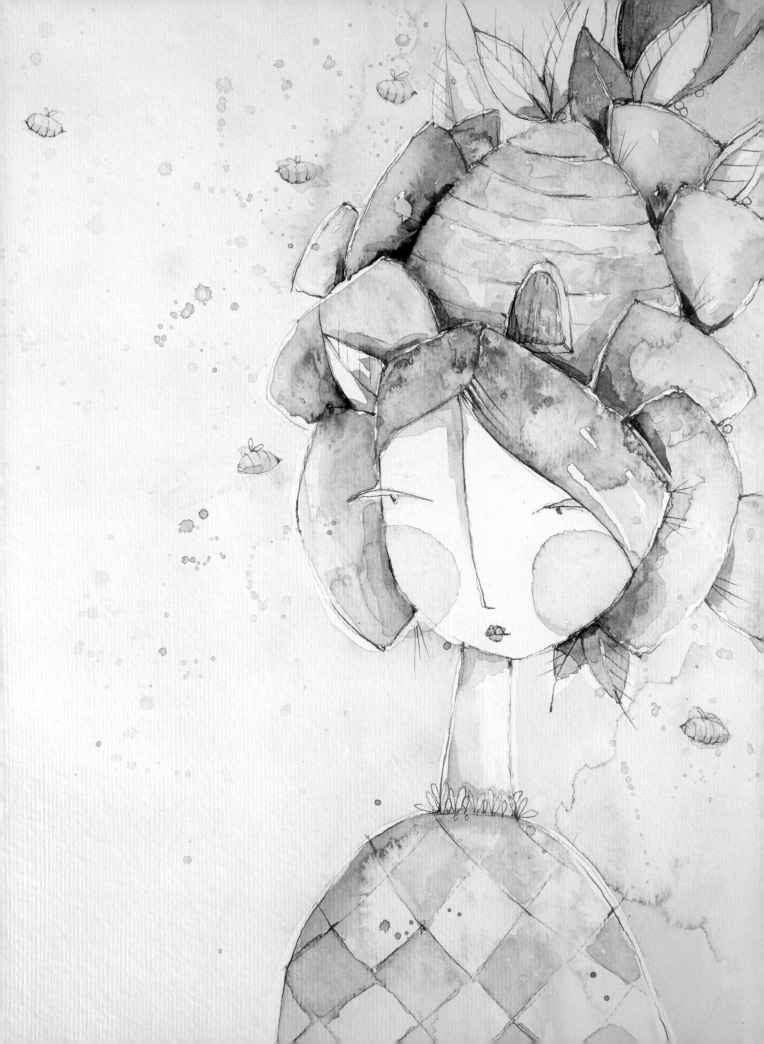

tutuGIRL

Full of sass and color, tutuGIRL is a great example of just having fun with watercolors. The layers of loose washes and simple details give you permission to worry less about perfection and play more with color.

MATERIALS LIST

6" × 6" (15cm × 15cm) watercolor paper

creative supply kit (see page 10)

magnifying glass (optional)

1 Sketch the Figure
Tape watercolor paper to whiteboard with artist tape. You can then use the top of the whiteboard as an additional palette to mix colors. Draw the sides and chin of tutuGIRL's head, her neck and an upside down U shape for her blouse. Add a few light and loose scribbles to give you a general indication of her tutu.

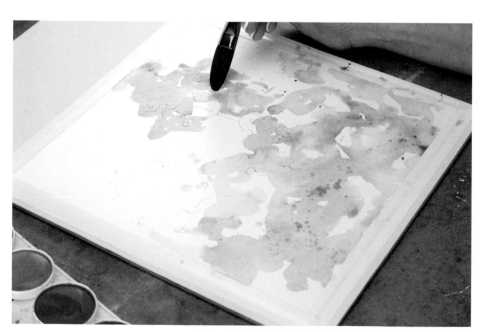

2 Add Loose Color
Add a loose wash of yellow and orange to start forming her hair. Add a second wash of blues, teals and purples to her tutu. Change your proportions of water and color in your brush. You want a balance of white paper, light color and more intense color to give the illusion of depth and layers in her tutu. Add salt and let dry. Brush away the salt when dry.

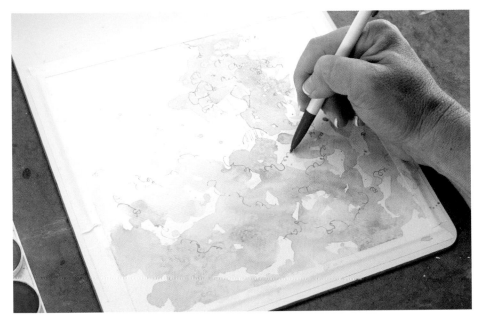

3 Pencil in Scribbles

Use your pencil to add scribbles to the tutu. Look for where different colors and intensity meet. Those areas give you a natural place to indicate layers of a tutu. Draw the remainder of tutuGIRL's head, creating her hairline on her face. Then add a part in her hair.

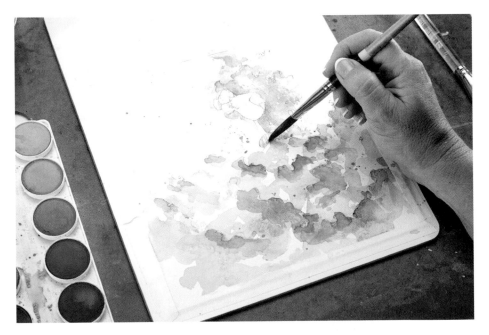

4 Add More Color

Add another layer of darker and more intense color to create the folds and layers of her tutu. Add shadowing to her neck and under her chin and behind her head to make the updo look like it is pushed back behind her head. Add salt and let dry. Brush away the salt when dry.

IT'S THE LITTLE THINGS

If using lots of colors and layers of fluffiness is getting the best of you, try simplifying your tutuGIRL. Try breaking down your process by using small scraps of watercolor paper. Draw micro-sized girls, leaving off facial features and limiting your use of color. Pay close attention to the white space around your girl while drawing her face, neck and top. After you have the drawing part under your belt, paint with one color. Work on developing her hair and tutu using your limited palette. Create another girl with just two colors. Once you have mastered the limited palettes, try all the warm colors and another with all the cool colors. After lots of super-small, focused practice and a better understanding of your process, you can grab some bigger watercolor paper and try tutuGIRL again!

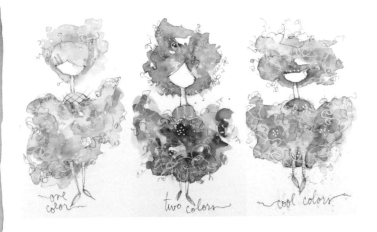

5 Add Facial Features

Add her eyes, nose and lips with your mechanical pencil. A magnifying glass is a lifesaver when I am drawing facial features on such a tiny scale.

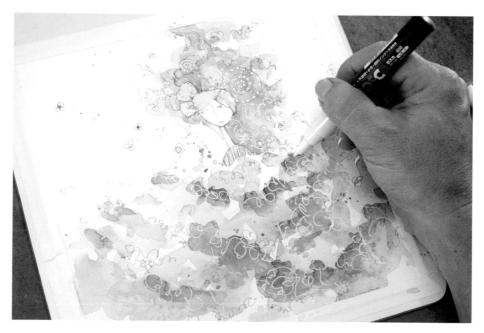

6 Add Final Details

Now that your painting is dry, are you happy with the depth? If it needs some darker colors in her hair and tutu, mix the original colors with black, brown or Payne's Gray and add another layer of toned-down color to the shadow areas you have already created. Remember to cut the size of the new layer of shadow by at least half. Let dry.

Because this is such a small girl, use a pencil with 0.3mm lead to go back and add doodles in the background, in the hair and in the skirt. Add white ink marker scribbles in the dark areas of her skirt to give the look of tulle, and add some dots or scribbles in the darkest parts of her hair. Finish the piece by adding a little pink to her cheeks and lips.

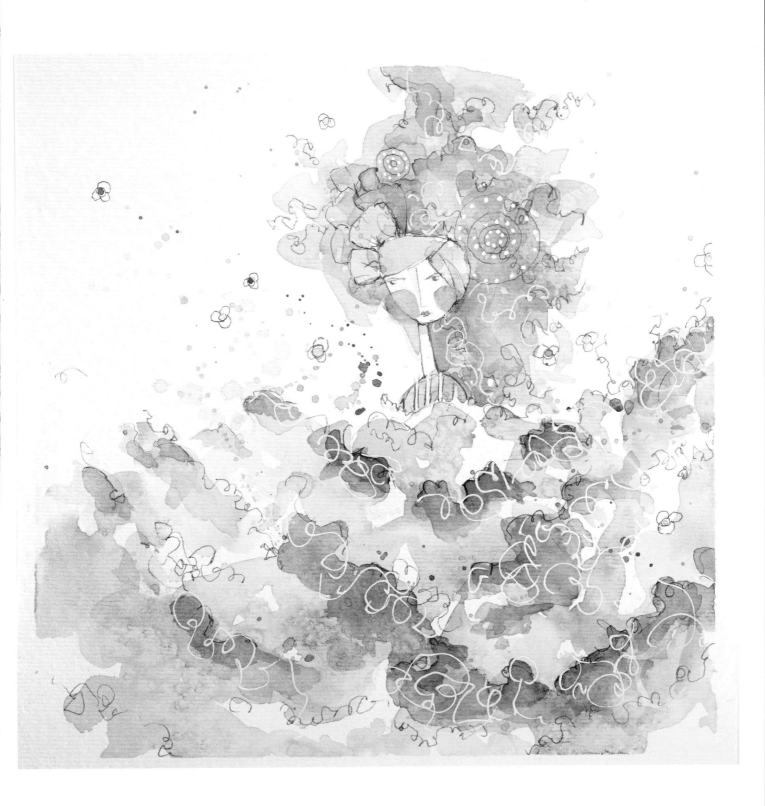

creativeGIRL

We all need a little reminder that we are way more creative than we think we are. CreativeGIRL is a pint-size cheerleader of all things creative. She whispers, "You've got this," in your ear when you can't seem to figure out how to get the picture in front of you to match the picture in your head. I've heard she even has a magic imagination that sparkles in her pocket, and she flings handfuls of it into your hair when you aren't looking. She has your back the minute you put your pencil to paper. So go dream up your version of this micro-dynamo, and set her up in a comfy corner of your world.

MATERIALS LIST

6" × 6" (15cm × 15cm) watercolor paper

creative supply kit (see page 10)

craft knife

decorative baker's string

Dr. Ph. Martin's Hydrus Watercolors

fabric scraps

patterned paper

ruler

sewing machine

scissors

1 Sketch the Figure
Tape watercolor paper to a clipboard and draw the basic parts of the girl: head, neck, buns, blouse and skirt.

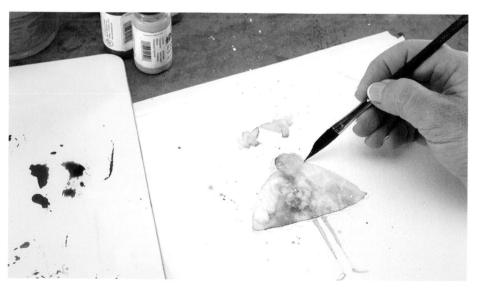

2 Add Color
Using your whiteboard as a palette, place a drop or two of a few different colors a few inches apart. Keep in mind that the liquid watercolors are very intense and you don't need very much to paint a small illustration. Add a mixture of warm colors to the dress and cool colors to her hair. Add salt and let dry. Then brush the salt away.

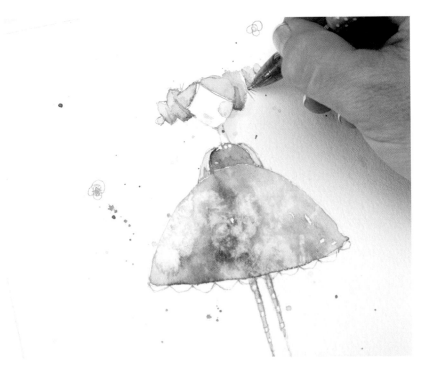

3 Add Shadows

Water down some of the black liquid watercolor and lightly add shadow and detail to the girl. Add more detail, pattern and visual tension to the illustration with a mechanical pencil.

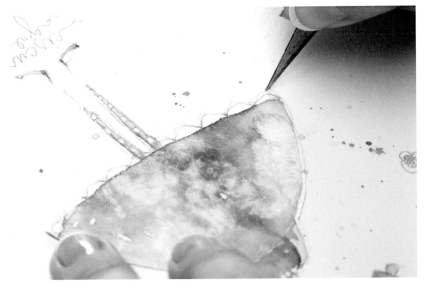

4 Cut Around the Skirt

Place the paper on a cutting surface. Using a craft knife, cut a line on the right side from the top of her neck, along her shirt and skirt, down her leg, until you get midleg. Repeat the same cut on the left side. Make a third cut between her legs.

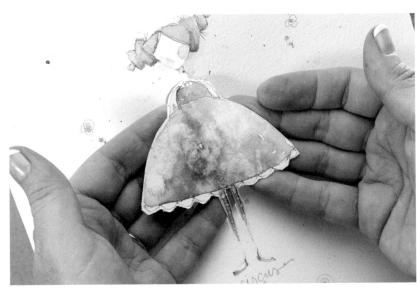

5 Lift the Cutout Figure

Slide your hand under the girl, separating her from the background. This is where you will insert her cape.

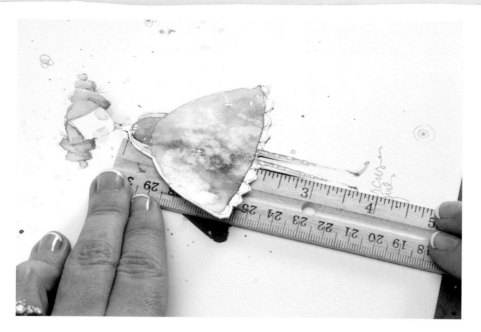

6 Measure the Figure

Measure the distance between the top of the cut on her neck to the bottom of the cut on her legs.

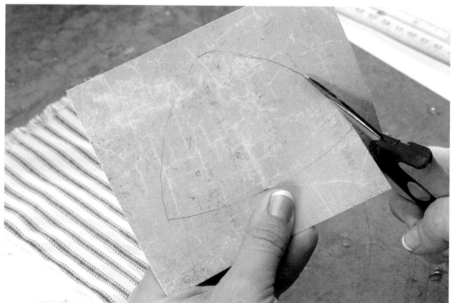

7 Cut Paper and Fabric

Draw a cape that measures just a bit smaller than the measurement you took in the last step. Cut the fabric a bit larger than the paper cape.

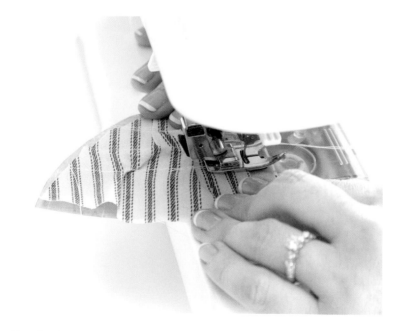

8 Sew Paper and Fabric Together

Starting at the top of the cape, sew the fabric to the paper cape with a series of horizontal lines. Gather the fabric as you go to add dimension to the cape and to allow the edge of the paper cape to show on all sides. This creates a sturdy border that you can use to easily insert the cape.

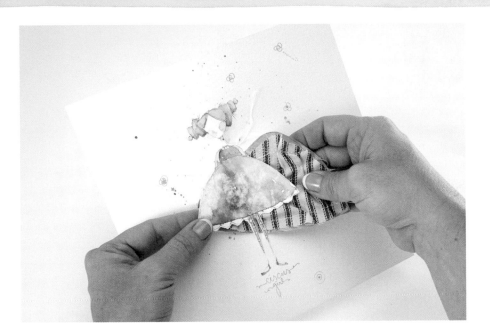

9 Final Details

Slide the cape under the girl's body with the background paper under the cape. Gently thread a small section of baker's string under the cut at the top of the neck, and tie it in a knot, creating the tie for the cape. Add little details to the background with your pencil and white marker as needed.

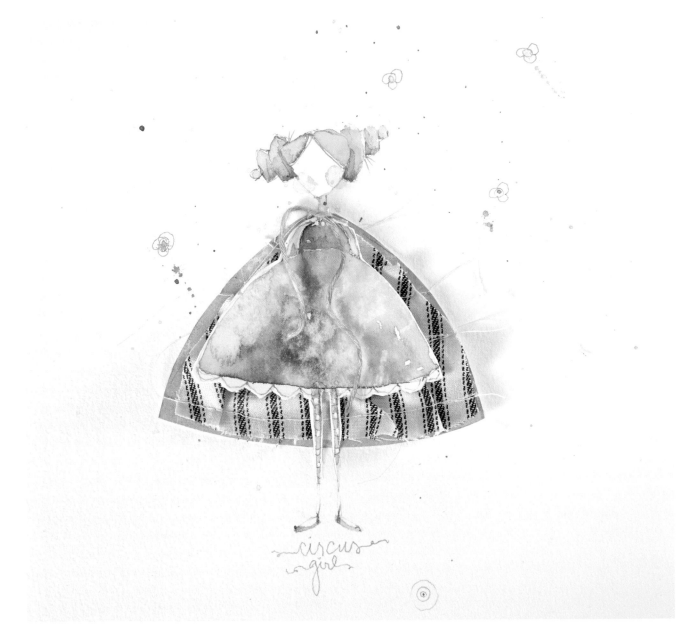

circus
girl

artEXCHANGE

When I feel uninspired by my own creative work and really inspired by some of my faraway creative friends' work, I jump on the opportunity to connect with them. And sometimes the roles are reversed, and I have noticed a creative lull in their work and want to spark their awesomeness. An easy way to connect is to exchange backgrounds or illustrations, even sketches, via mail. Once in hand, you can study how your friend's piece works, add your own spin and share some magic. Sometimes I send the piece back and sometimes I keep it. Either way, I feel less like I am on a creative island and more like I am at a creative pajama party!

Danielle's Thoughts

My friend Kelly Barton lives forever and a day away. Although we chat or text almost daily, I miss getting to sit next to her and soak up her amazing use of colors, pen work and wicked giggle. We both draw girls, but in totally different ways. I thought it would be fun to see how each of our illustrated girls would look if we swapped and added our own creative process to the mix.

Before adding my spin to her work, I took some time to really study her illustration. She is the master of line art. Her ability to weave lines together with changes in width along the angular curves gives her girls such confidence and strength. My girls, on the other hand, are drawn in pencil with much softer, sweeping curves. I rely on my addition of visual tension in the last stages of my process to create the boldness she has from the very beginning.

Kelly's Thoughts

Danielle is my girl in warmer lands. We first met long ago at a gathering on the Oregon coast. Her wicked sense of humor had me at hello. She is my creative muse, that voice of reason in my ear, and I have to say, if we ever get in a room together for more than a couple of hours, there will be a color explosion. Anytime I get to work with her, I almost drool. We have had several creative collaboration challenges that we played around with,

and this one, well, I wasn't too sure how this was going to work out. But when I opened her illustration, I had to sit back for a bit and ponder on how I was going to add the kellygirl to the cutegirl. Danielle's technical high jinks always sway me; I can become a little nervous. But as I reminded myself of the task at hand, I was able to think about her skill of allowing colors to build softly into layers that are so rich and packed full of story. And so I began.

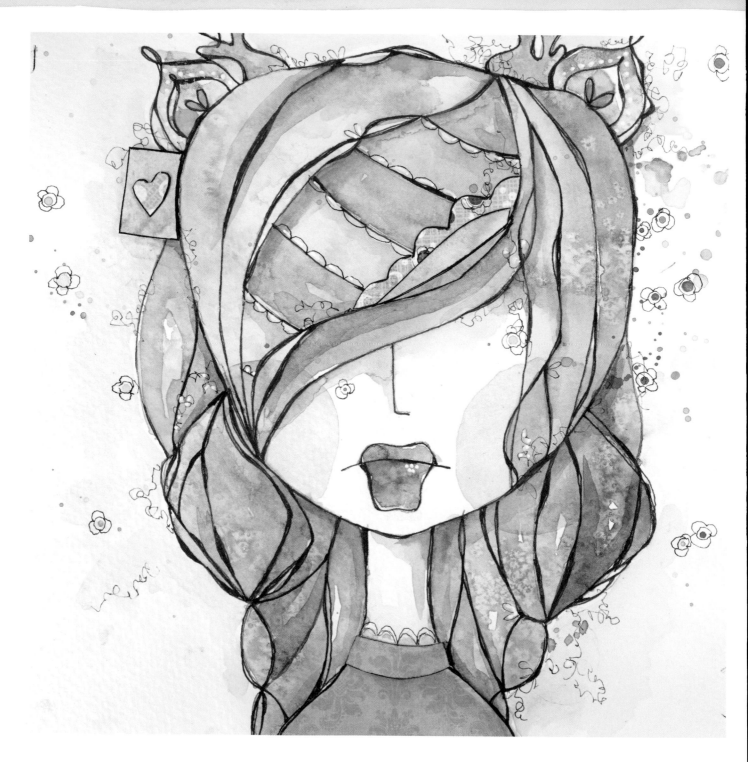

Danielle's Thoughts

I added color and all of my doodled bits, and covered up a trouble spot with patterned paper and a heart. The girl in the drawing became this colorful version of both of us, mixed in the most perfect of ways.

The process also reminded me of how much Kelly has inspired my work since we met at a retreat several years ago. I thought she was "the cool girl," and it took me almost the whole retreat to make my move and chat with her. Since then she has consistently made me laugh and cheered me on and reminded me that she is walking right next to me, every single step of the way. When you look at our final pieces, you can see how we work with each other. Rather than fret over how much our work has in common, we take the opportunity to help each other grow. And we get some great art to frame in the process!

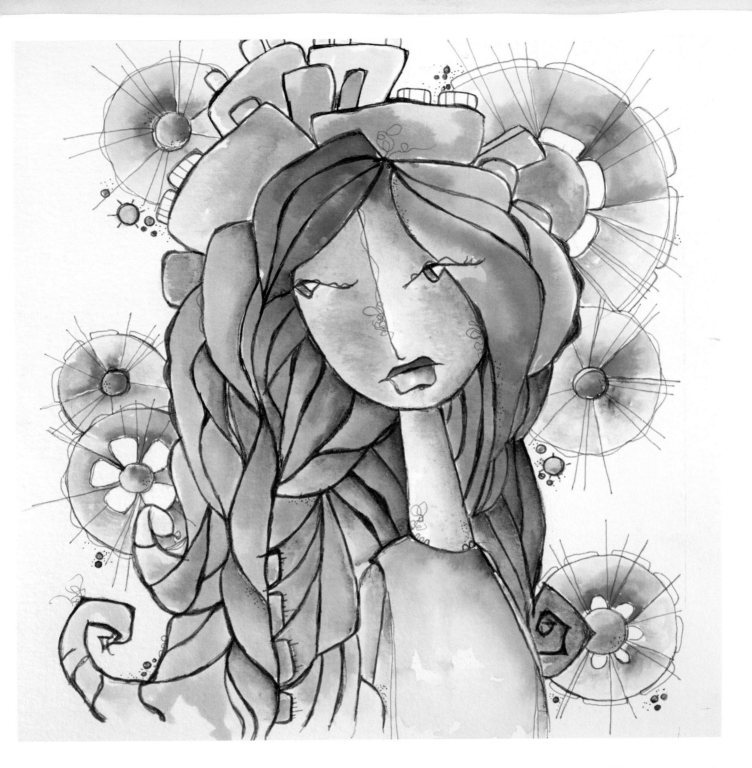

Kelly's Thoughts

I almost always begin with my trusty pencil. Gently drawing in soft lines, moving around Danielle's girl, adding in the bits of me. There were a couple of moments when I didn't want to continue, wondering how on earth I could make our two styles meld together in a way that would allow both to shine. Then it came to me: Add in the blossoms. Then add the color and finally the line work that I love the most. The line work is where, on any piece, I can truly see my style. And there she was. A bit of me and a bit of Danielle.

Working through those moments of "oh, no, this might not work" was a reminder of the bits of me and the bits of her, and why we are such kindred spirits. We each hold wicked creative vision, and we were thrown together so we both carry that reminder. Sometimes I call her "danidoodlesallthedaylong." Just looking at these two girls, filled with each of our colors, I can see how two girls can create together, respect one another's talents with little worry of being too much alike, and cheer as each grows and moves along her path.

6

hotMESS

I have my own way of getting to the finished piece. I have a tendency to work through a new piece in my head first. Usually, I do most of my drawing on the couch. Then I head to the dorm room (my studio) and add my first layer of watercolors. Then I walk away for a while. Or if I am really excited about it, I'll turn on my craft dryer to speed up the process. I brush away the salt and smile at the initial magic of it all. The piece comes back out to the couch (or maybe the kitchen if it's dinnertime), where I add another layer of pencil work. Then back to the dorm room for some more color. And somewhere between trips, it turns on me. Maybe I added too much of one color. Maybe I added shadows where there should have been light. But most often I have no idea why my head is telling me, "Wow, Danielle, that is a hot mess! What the heck?"

And I am frustrated, mad, irked. And for a brief moment, I consider the piece ruined. That happy colorful magic has lost its shine. I may even stomp my feet or call myself an unkind name. Dramatic and pessimistic, I know. Each artist has their own name for this stage. Mine is "the hot mess stage."

It is really important for you to know that every artist experiences this stage. Every. Artist. Online class videos, how-to books and social media can be deceptive from this standpoint. They often leave this stage out. And I wish they didn't. I think this stage is often the most important stage. It is our opportunity to give ourselves grace and to problem solve. It allows for a little self-reflection and therapy. It makes us figure out how to work through the discomfort of it. For me, the key is taking the time to identify what the issue is rather than just "letting it go."

So when you are working on projects, cut yourself some slack when it just isn't working and walk away for a bit. It will be exactly where it was when you come back. I promise.

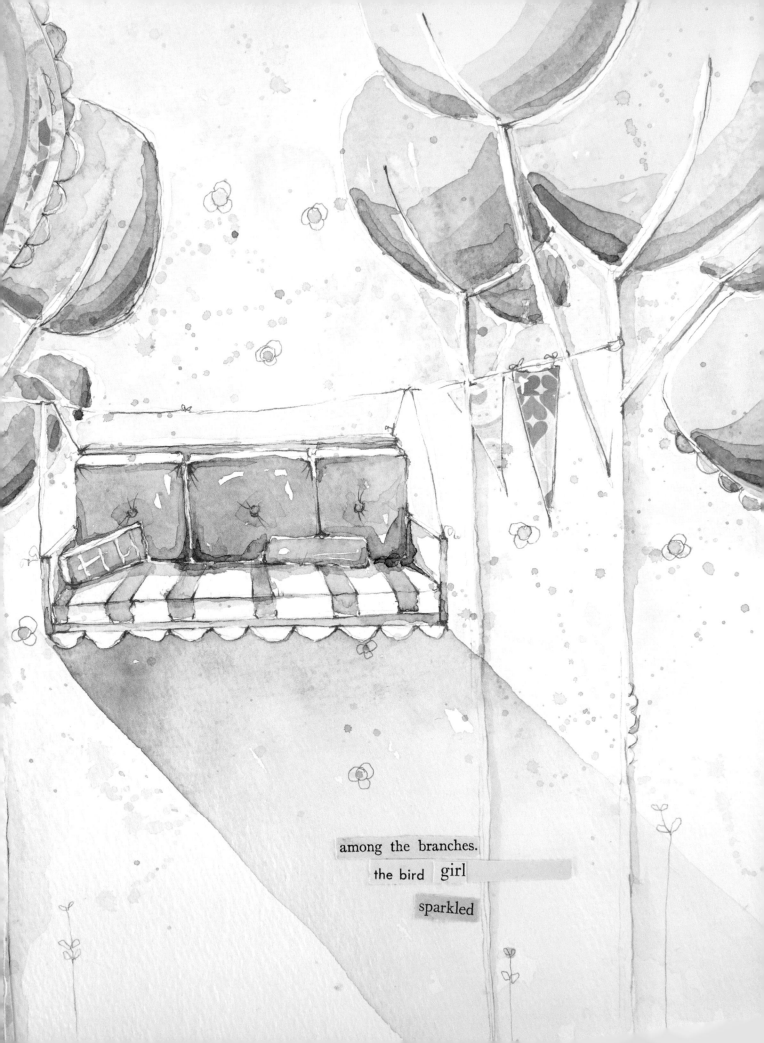

among the branches.
the bird girl
sparkled

my go-to hotMESS solutions

Pick and Choose — Save the best parts of an old, ugly or worn-out piece. You can do this by cutting it apart and adding your favorite bits to your stash and throwing the rest in the trash. Doing so is highly therapeutic.

Cover-Ups — Cover up an old or sad piece altogether; either with paint or paper. You can also cover up the parts you don't like anymore with paint, patterned papers and ephemera. All of these options work well and give you a multitude of new surfaces to paint on, allowing you to incorporate the bits you preserved and blend them in with the new. This is my favorite technique with panels and canvases, and it works well when the majority of the piece is not your favorite.

Work-Arounds — Identify the part of a piece that bugs you, then dig into your stash to fix it. This allows you a more positive solution than painting over a little spot or reworking it, which usually only leads to one thing—hating it even more. That spot already had *your* attention, now it has everyone else's too! Instead of letting go of the little spot that didn't work and focusing on the rest of the piece, you managed to turn the little spot into the focal point of the piece. I am not sure why we are programmed to do that, but we are. Allow yourself the time to mull it over and think of how to make it shine, rather than

disappear. At the very least, set it aside and take a break. Then come back and work around it.

Walk-Aways — Allowing yourself the opportunity to set a piece aside and disconnect for a while. If your creative brain works anything like mine, you will actually imagine up a brilliant solution, given a little bit of grace and a decent amount of time. Some of my best ideas come after I have stomped away, when I turn in for the night and my head hits the pillow. And if that doesn't happen, tuck the project away behind a box somewhere. You will discover it down the road, and a new technique or supply will be just what you need to finish the work with a smile!

Let It Go — Allow yourself the opportunity to value your time and energy by tossing work in the trash. We tend to invest ourselves in our art so early in the process that we don't allow ourselves to just let something go. It isn't working. It's not like what you imagined. Let. It. Go. Your time and energy are worth more than the product you used.

It's OK to Have a Bad Day and Be in A Bad Mood:

I am a perfectionist and a morning person. I am a planner, a list maker and a full-time worker bee. I am a mom, wife, daughter and friend. I am a creature of habit and a hermit. I am loyal, sensitive and worry about pretty much everything. I am happiest when

my mind and hands are busy, and my daily creative practice is often my reset button at the end of a busy day. But there are days that just don't feel the creative love. At all. On those days, I want nothing more than to create my way out of my bad mood. Some days I am successful and other days, I can't draw a stick figure to save my life.

It's OK to have an off day, and sometimes it's OK to just not push your luck and to offer yourself the opportunity to do something else. Anything else. Just walk away and come back another time.

Practice Doesn't Make Perfect But It Does Help:

I find that I can move most of my art forward if I can identify the trouble spots and work with them instead of against them. But sometimes it is bigger than a spot or two. Usually, for me, it stems from the very start of the piece; I didn't spend enough time practicing how to draw what I am trying to draw. My mere love of horses and an epiphany that my next new thing is going to be a watercolor series of colorful long-legged ponies does not automatically make me an equestrian-drawing aficionado. You have to give yourself the opportunity to practice before you throw yourself into the series you have envisioned. Skipping the practicing part is a quick path to frustration.

Wow, You're Deep:

One of my favorite steps in my creative process is to add depth to my work. I add depth by varying the size of objects in the foreground and background, by using perspective drawing and by adding shadows and highlights. Perspective drawing was one of my favorite classes ever. (Weird, I know!) The whole concept of being able to make things look like they are jumping out or fading away is just awesome.

When your perspective is off, you know it. For me, the only solution is to get better from the get-go. While my techniques and step-by-steps give you some basic insight into how I add depth, there is so much more you can learn! Dedicate an entire journal to adding depth to objects and scenes using perspective drawing, take an online course and find a great reference book and practice. The beauty of perspective drawing is that once you get it, your work will grow by leaps and bounds and there will be about a gazillion new subjects you can draw and paint.

Sometimes Less Is More:

White space is an integral part of my work. By definition, white space is the negative space—the empty space that allows the artist to create visual focus on the object(s) in the piece. In graphic design, it is the blank space between lines of type, the gutters and even the space between a title and a subtitle. Either way, awareness of what isn't there is as powerful as what is there. For me, it's the absence of clutter; it's a deep, calming breath; it's imagination. And it is as important as anything you might draw or paint.

To create white space, resist the urge to fill up every nook and cranny of your paper, canvas or panel. Try to be aware of trapping white space as well. Look at your drawing and ask, "Did I create a shape with white space that distracts the viewer?" Think of these spaces as trapped bubbles that just bounce around instead of floating away. A great way to avoid the bubbles is to be sure to allow some elements of your drawing to bleed off of the paper or canvas.

Finding Your Balance With Color:

Have I mentioned my deep love of all colors? For me, the overall balance and use of color is really important. I have a pretty darn good nose for color and can sniff out problems and resolve them pretty quickly. It's a gift, and I am very thankful for it.

If the overall palette seems lacking or unpleasant and you are having trouble identifying why the color scheme is out of balance, grab your rainbow reference strip. Run through each color of the rainbow and ask, "Is there too much or too little?" Once you have worked through all of the colors, it is pretty easy to determine what color you should choose to balance the piece. You can even take your questions up a notch and for each color of the rainbow ask, "Is it a good balance of cool and/or warm colors?" If you find that you have added colors that have thrown off the balance, consider starting over or repurposing the piece altogether. I know it can be painful, but you learned something valuable about color. And in the end, working on a new piece is a better use of your time than working to fix one that may or may not be able to be fixed.

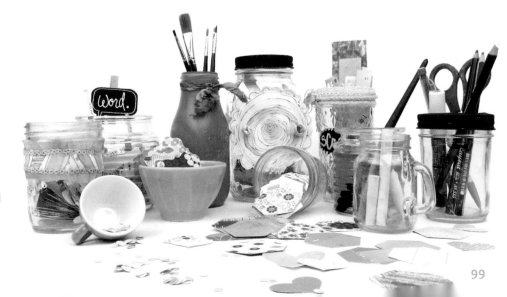

creativeGIRL gets a makeover

Sometimes you love something as soon as you finish it. Sometimes you like it but know that it is "off" somehow. When frustration sets in, you have to set it aside and walk away. Then you can come back with some happy magic and a stash full of color.

CreativeGIRL was not balanced. It came to me when I was sewing the cape. I love green. It is my favorite color. But creativeGIRL kept whispering, "Trick or Treat!" in my ear over and over again. And she was getting on my last nerve. It was time for a change.

MATERIALS LIST

clear craft glue

creative supply kit (see page 10)

scissors

vintage storybook page

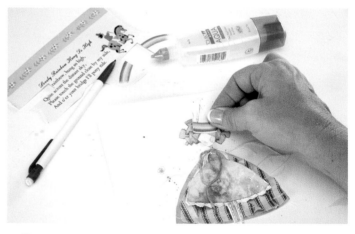

1 Change the Hair
After setting her aside for a few days, I brought her back out to have a chat. I loved her two simple buns, but I knew that if I added a few more, along with some color that coordinated with green, the change would provide more color balance.

2 Add a Party Hat
Even after adding the blue and purple, she seemed unbalanced. I decided to cut a party hat out of a page from an old children's book. A rainbow band at the bottom of it was the trick that turned her into a sassy little treat!

See the original creativeGIRL in chapter 5.

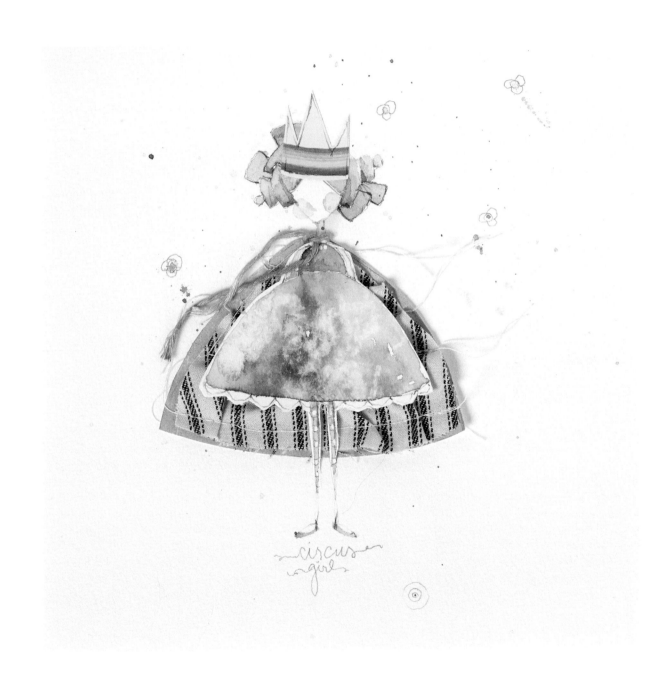

circus
girl

busyGIRL was boring

Don't get me wrong. I love her. I had just gotten a pretty new pink pan watercolor to add to my set, and she was just the illustration to test it out. Still, she seemed flat. I had given her depth with lots of layers of pencil work and deeper hues in all the right places. She just didn't seem 100 percent on board the Danielle-color-train. And she had one of my infamous little trouble spots. Right next to her eye, there was a inappropriately placed shadow on one of the buns. (And yes, I am very picky. Hence the need for grace, and lots of it.)

MATERIALS LIST

clear liquid glue

creative supply kit (see page 10)

scissors

stitched watercolor scrap (see pages 50-51)

watercolor coffee filter (see page 48)

1 Cut Out Leaf Shapes

After giving busyGIRL a break from my meticulous eye, I felt like I could tackle the little funky shadow and balance the color with a few snippets from my stash. I pulled out my rainbow array of coffee filters. I ran through the colors of the rainbow and felt like she was missing orange. Choosing an orange filter and folding it a few times, I cut several simple leaf shapes. I added the first leaves to my problem spot and then repeated them in various places so it wouldn't look like I was just trying to cover the problem spot. Regardless, it's always a good idea to repeat a pattern, mark or embellishment. A group of three is often a good balance.

2 Add Leaf Shapes to the Hair

After dealing with my trouble spot, I noticed that my eye naturally went from the hive to her face and to her frock, and then right off the page. Not good. Adding more detail to the dress would circle my eye back around, strengthening the overall composition of busyGIRL. I dug through my stash and found the paper that I had stitched together and painted. I cut and glued a piece to fit across the bottom of her frock and added a bit of antique lace as a finishing touch. It not only fixed the composition problem, but it added dimension to the bottom of the piece which complemented the leaves I had added to her hair. Mission accomplished!

See the original busyGIRL in chapter 5.

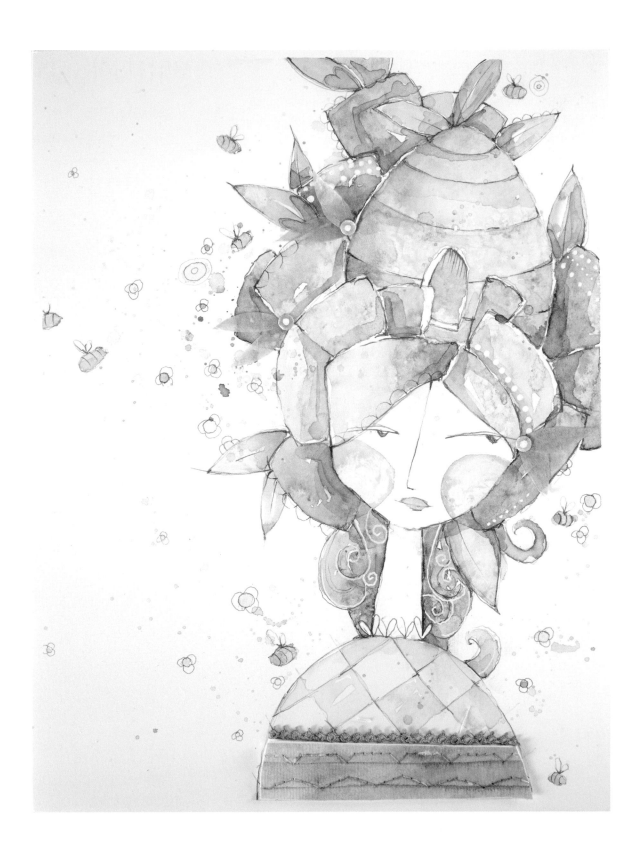

how did I miss that?!

Have I mentioned I am a bit of a perfectionist? I was putting the last little doodles on the tree swing piece and realized that I had completely missed adding any color or shadow on a good portion of the large tree on the left side. Dang it! Time to dig into my stash and add some fun snippets of patterned paper.

MATERIALS LIST

clear liquid glue

creative supply kit (see page 10)

patterned paper scraps

scissors

1 Cut Shapes From Patterned Paper
Choose three scraps of patterned paper that complement the painting by adding a little pop of color that might be lacking anyway. Cut little flags, a strip of paper to fit in the area of the tree that was overlooked in the initial layers of watercolor, and another strip for a tree trunk.

2 Adhere Paper to the Piece
Adhere the paper to the painting using a small amount of liquid glue. Let dry. Add some pencil work around the cutouts, blending them into the painting to be sure they don't end up looking like an afterthought. Remember, when you add details like this, you want to make sure you place them in a few different areas of the painting to be sure the additions look like you planned them all along!

See the original chair swing piece in chapter 4.

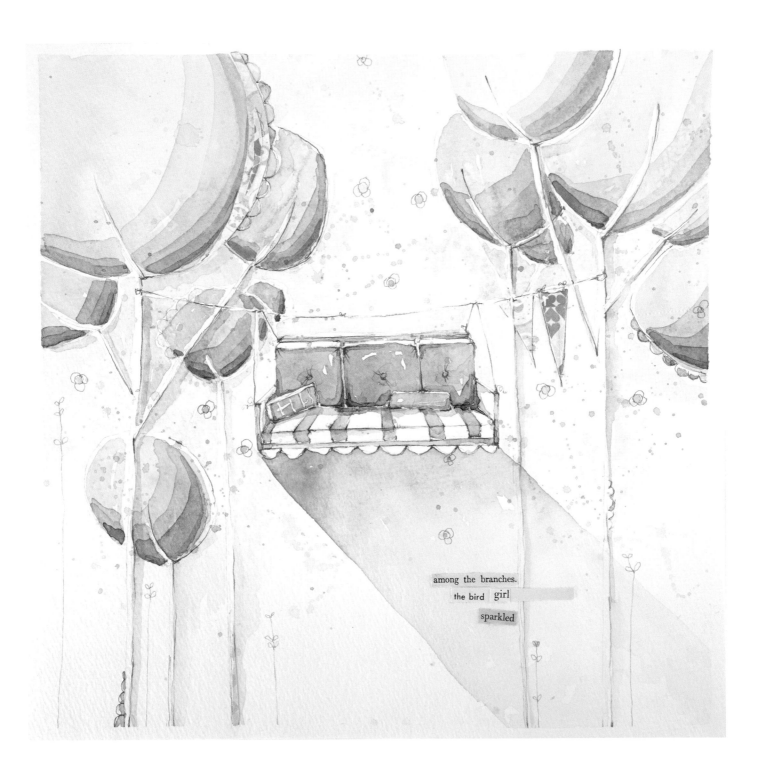

among the branches.
the bird girl
sparkled

creative REPURPOSING

I have a huge collection of my own stuff. HUGE. Stuff I thought I would sell and made a dozen of. Stuff that I made at retreats that is less than beautiful but has sappy sentimental value. Stuff that actually made it on my walls only to stare back at me and say, "Hey, Danielle, you thought I was awesome. Don't you dare take me down because I will cry." (Yes, even my paintings chat with me—some form of art guilt I suppose.) I have half-finished pieces, which is a rarity in my world because I am very determined to make things work due to significant investments of my time and my heart. There are train wrecks in the form of art, created on costly canvases or panels with layers of expensive paint that I can't seem to throw away. My collection is rounded out with a plastic bin full of pieces that I created and love but don't have wall space for. Those are the hardest.

This used to torture me for a multitude of reasons, but over time I have found a way to mash them together, rip them apart and creatively repurpose them. It allows me to look at my work in a new way, with new energy, and make it mine all over again. Repurposing gives me the freedom to hold on to just the bits and pieces that speak to me. It allows me the opportunity to work with something I loved and now only kinda like, and add life to it. Then I can fall in love with it again.

Basically this is where new ideas buddy up with unfinished projects, artwork gone awry and pretty stuff from the past that has worn out its welcome.

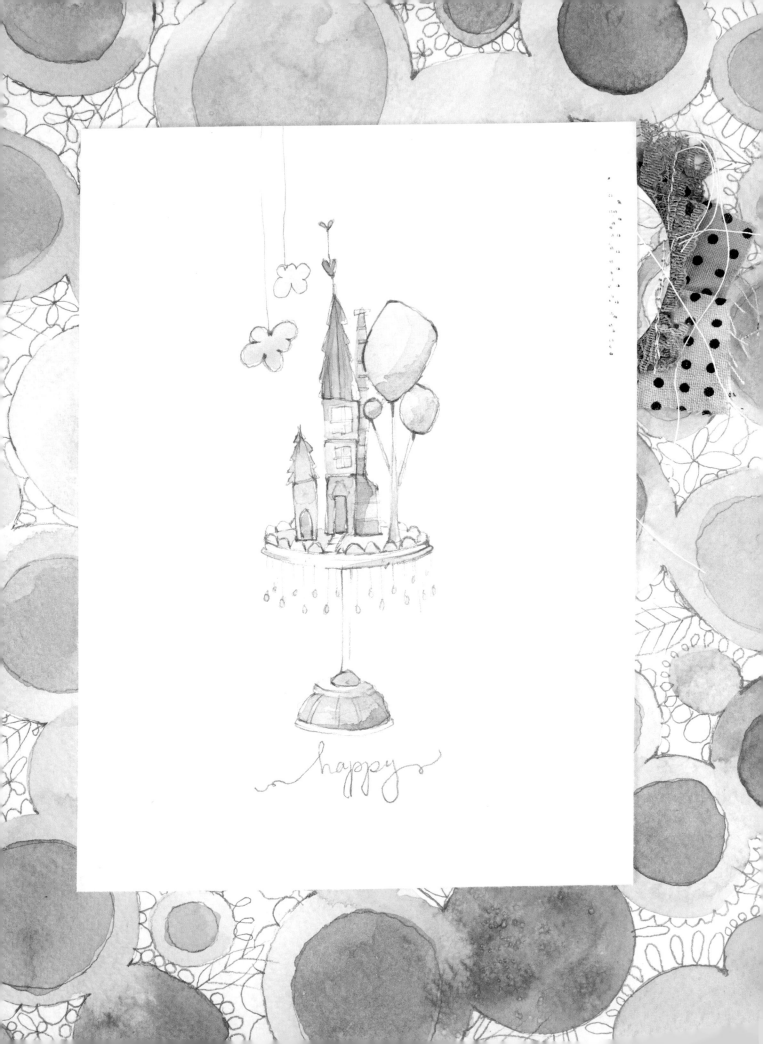

happy

patchwork panel

I hate it when I start a piece on an expensive panel and get about ten minutes into it and know I don't like it. In the past, I would work it into submission, which was an utter waste of my precious creative time. Now, I just tuck it away with my new or unfinished (or unlikable) panels.

Remember how I said I have a bin of artwork that I love but never sees the light of day? For this creative repurposing project, I take a few of my favorite little watercolors, an ugly panel and some patterned paper, and turn them into an abstract piece of art. It's a perfect addition to a space that displays a few of my other pieces.

MATERIALS LIST

- clean brayer
- craft brush
- craft knife
- Mod Podge
- old and/or practice watercolor pieces
- patterned paper scraps
- sewing machine (with white thread)
- scissors
- ugly birch panel

1 Cut the Paper
Gather up the materials you want to use for this repurposing project. Cut old watercolor pieces and patterned paper into strips of various widths.

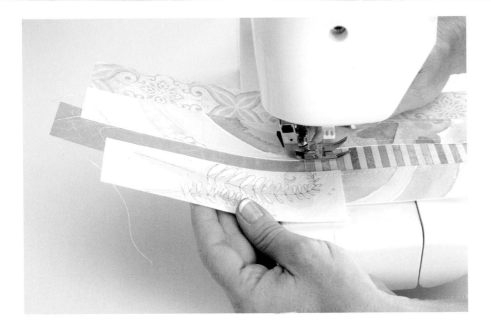

2 Start Sewing

Using a variety of stitches for visual interest, begin sewing the strips together.

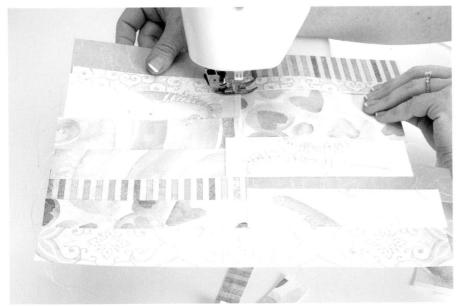

3 Finish Sewing

Continue sewing the strips together until the overall patchwork of paper is large enough to cover the birch panel completely.

4 Measure the Panel

With patchwork paper facing down on a clean, flat surface, place panel face down and trace around the perimeter of the panel. Use scissors or a craft knife to trim the excess.

5 Add Mod Podge

Brush a generous layer of Mod Podge on the panel and the back of the patchwork art.

6 Adhere the Patchwork

Carefully place the artwork on the panel and press down to get correct placement. Once it is lined up correctly, use a clean brayer to work out any bubbles and get a good seal between the paper and the panel. Let dry. It may be helpful to put some weight on the piece while it dries to ensure a nice flat bond.

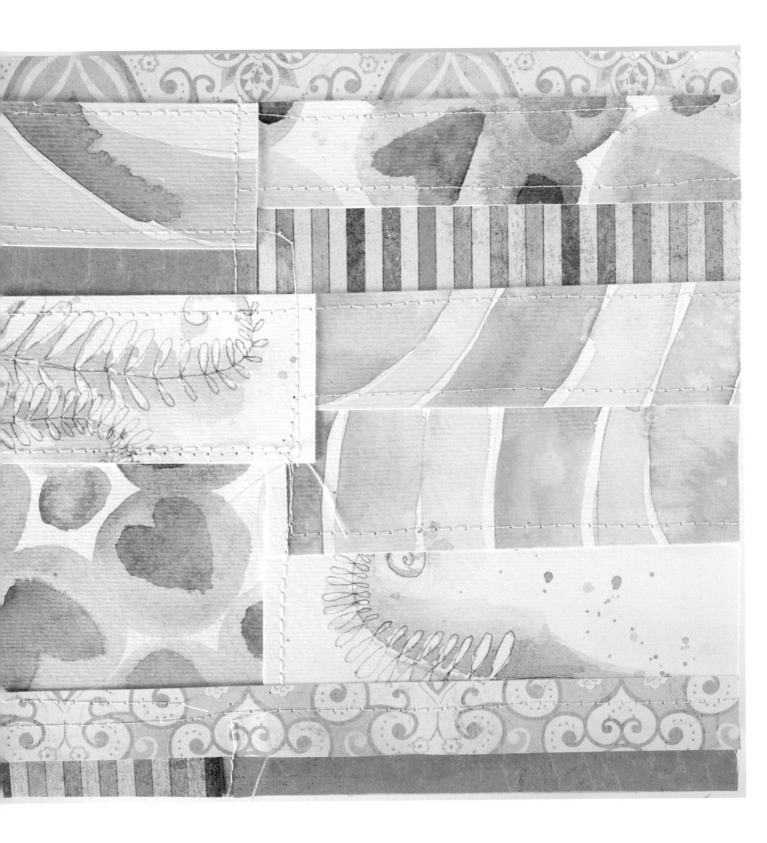

happy

One of my favorite creative repurposing projects is pairing up practice pieces or rejects from my stash with micro illustrations. The finished piece is always so much more fun than it would be if you used a plain mat and frame. It also pulls together different-sized patterns and textures, creating much more visual interest.

MATERIALS LIST

clear craft glue

micro illustration (can be a new illustration or maybe a watercolor sketch cut out from your sketchbook)

practice sheets of colorful doodles

sewing machine

scissors

watercolor fabric and lace scraps

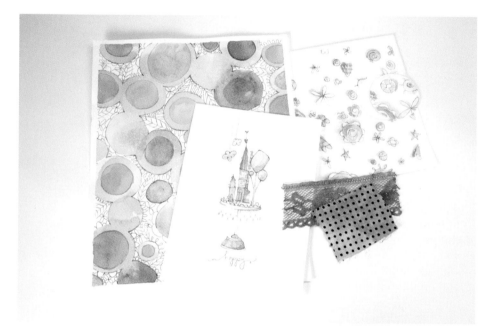

1 Gather Materials
Grab the piece you want to repurpose, as well as a background and fabric from your stash.

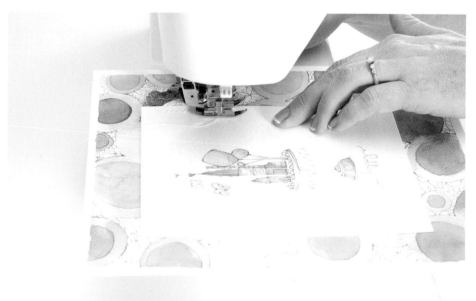

2 Sew Pieces Together
Use your imagination and scissors to assemble a little collection of paper, fabric and lace to tuck under an edge of the illustration. Think of it as a quirky decorative tab. Layer your background, tab and illustration. Using the zigzag stitch, stitch the layers together in the corner. Remove and glue the rest of the illustration to the background piece.

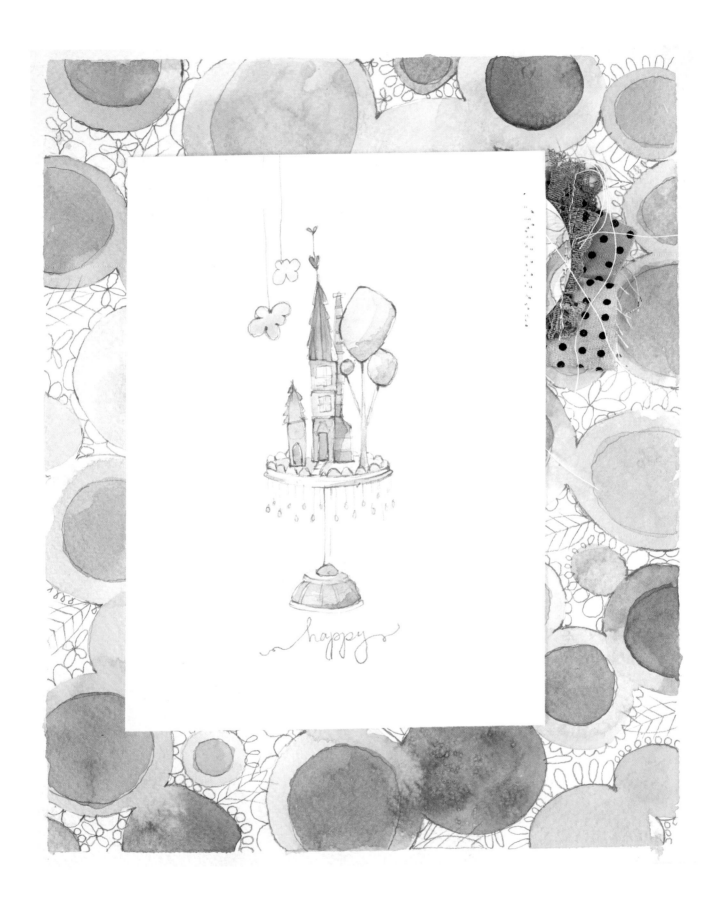

happy

polka-dot paint brushes

I hate it when I finally have a whole afternoon set aside to create my next, most wonderful masterpiece and as soon as I sit down, I have nothing. All I can hear are the crickets, followed by my own voice expressing a small level of panic that I might have possibly run out of ideas forever.

When you hit creative roadblocks, challenge yourself to use only stuff you have in your stash or trash to create something beautiful. In a way you are giving yourself a break and recharging your creative batteries at the same time.

MATERIALS LIST

clear craft glue

creative supply kit (see page 10)

painted birch panel

patterned watercolor stash

scissors

1 Gather Materials
This project doesn't need much to create something new. Grab a piece of collaged watercolor paper from your stash and a painted birch panel.

2 Draw Brush Handles
Using your mechanical pencil, draw brush handle shapes onto different areas of your patterned watercolor paper.

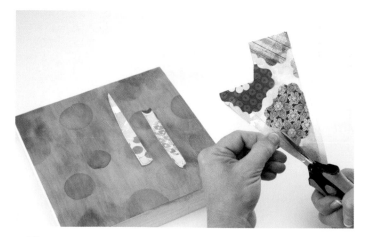

3 Cut Out the Shapes
Cut the paper brush shapes. Don't cut directly on the line, cut just outside of it to create a margin. Position the paper handles, taking into account the room you need to leave to add the bristles. Once you are happy with the placement, glue them down. Let dry.

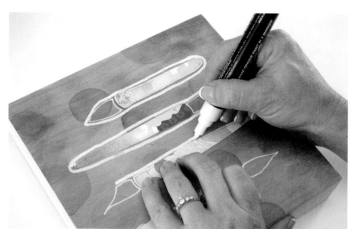

4 Outline With White
Using your mechanical pencil, sketch the shape of the brush at the end of the handle. Then go over it with a thin, white marker. Outline the entire paintbrush with a medium white marker. Be sure to leave a small margin between the paintbrush and your white outline.

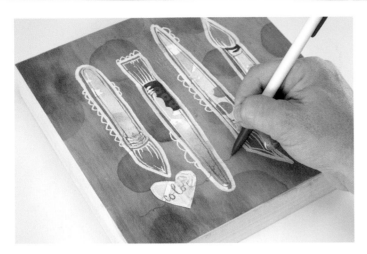

5 Add Final Details

Use your thin, white marker to add details to the bristles, the ferrule and the handle. Adhere a small paper heart cut from a paper scrap. Write the word *color* on the heart with your mechanical pencil. Add a layer of visual tension with your pencil, and the project is complete!

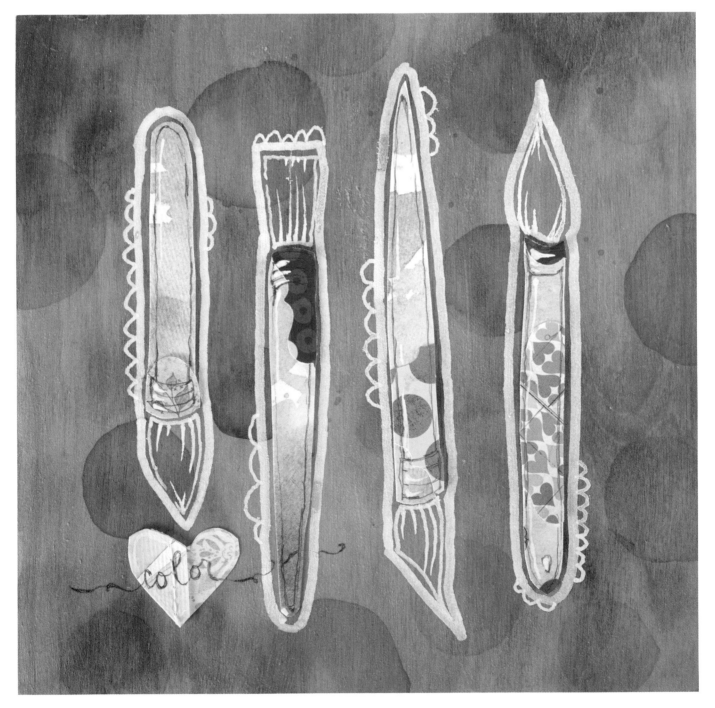

8

extraLOVE

Here's a little gathering of some of my creative eye candy to show you just a few of the amazing things you can imagine up using watercolors as a basis for your beautiful mixed-media projects.

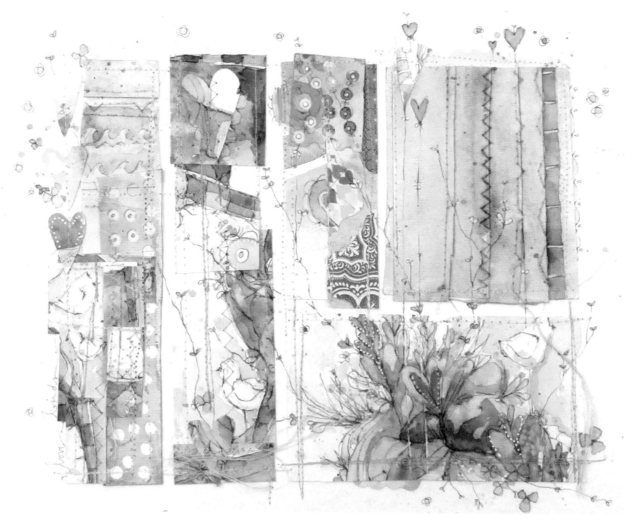

Lovebirds
Mixed-media watercolor collage.
Supplies used: watercolor and layering stash, mechanical pencil, scissors and sewing machine.
Techniques used: sewing scraps, using scraps and repurposing art-gone-bad.

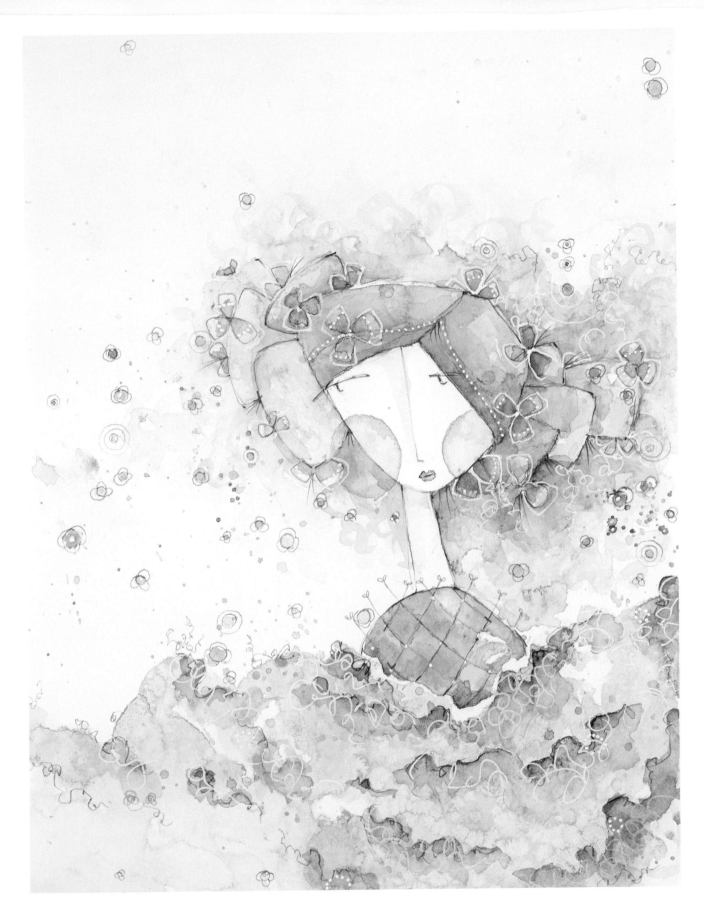

coverGIRL NO. 2
Illustrated watercolor on paper.
Supplies used: pan watercolors, white ink and mechanical pencil.
Techniques used: Adding shadows with color, visual tension and white marker work.

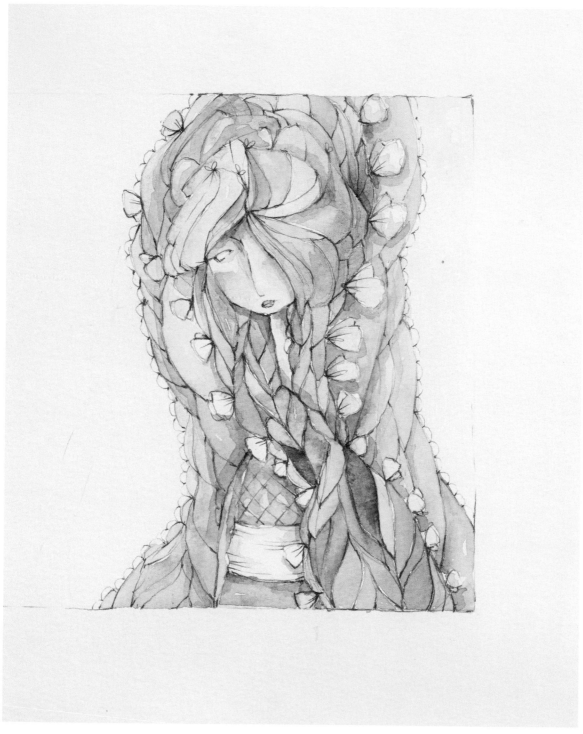

knottedGIRL
Illustrated watercolor on paper.
Supplies used: pan watercolors, white ink and mechanical pencil.
Techniques used: Bright and pale washes to add depth and lots of couchCREATIVE time drawing doodles and visual tension.

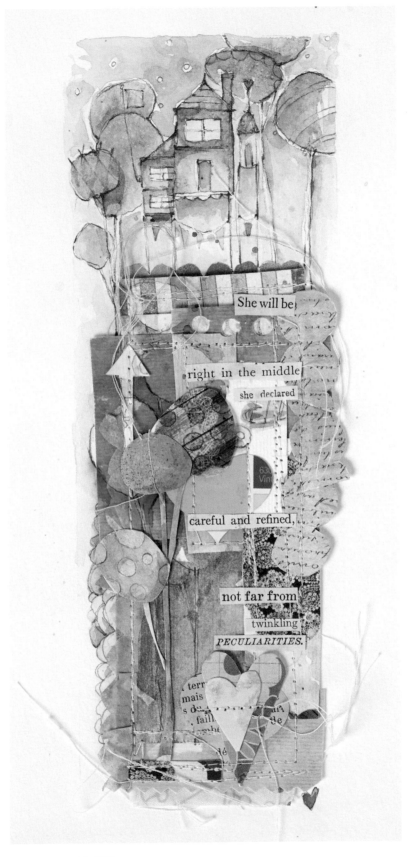

Within the artwork, the following clipped words appear:

She will be

right in the middle

she declared

careful and refined,

not far from

twinkling

PECULIARITIES.

twinklingPOSSIBILITIES
Mixed-media watercolor on paper.
Supplies used: mechanical pencil, pan watercolors, patterned paper and word jar stash.
Techniques used: Stitching stash pieces, adding illustrations to nestle into the stitched collage, and
creative story-telling with clipped words.

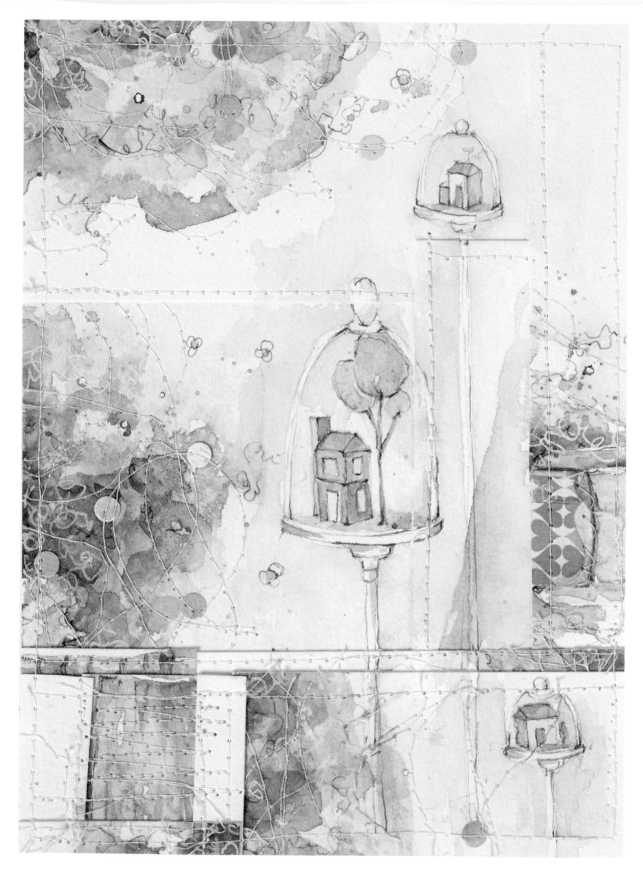

closeIN
Mixed-media watercolor collage.
Supplies used: pan watercolors, mechanical pencil and handmade watercolor confetti.
Techniques used: Drawing on a small scale and adding imagination, cutting apart art work that
went wrong and stitching it back together to give it new life.

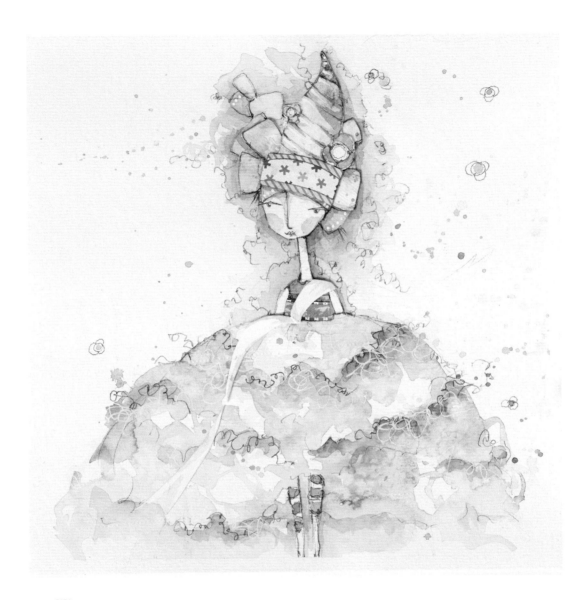

partyGIRL
Illustrated watercolor on paper.
Supplies used: pan watercolors, mechanical pencil and patterned paper.
Techniques used: Layering cut bits of paper and watercolor stash, hiding some not so pretty parts
and adding depth at the same time.

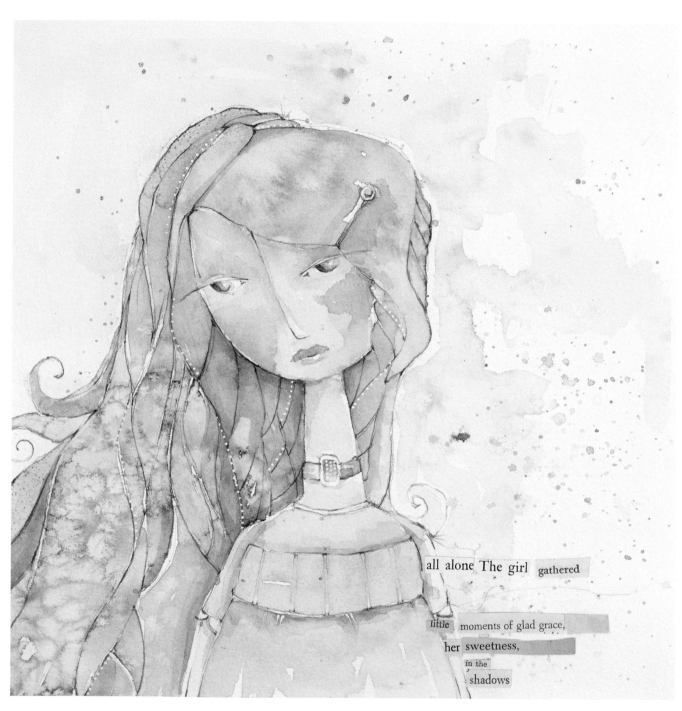

all alone The girl gathered

little moments of glad grace,

her sweetness,

in the
shadows

allALONEgirl
Illustrated watercolor on paper.
Supplies used: mechanical pencil, pan watercolors, salt, word jar stash.
Techniques used: Beautiful washes of color created with salt, additional layers of mud around her
face to give depth to her hair and a dip into the word jar to tell her story.

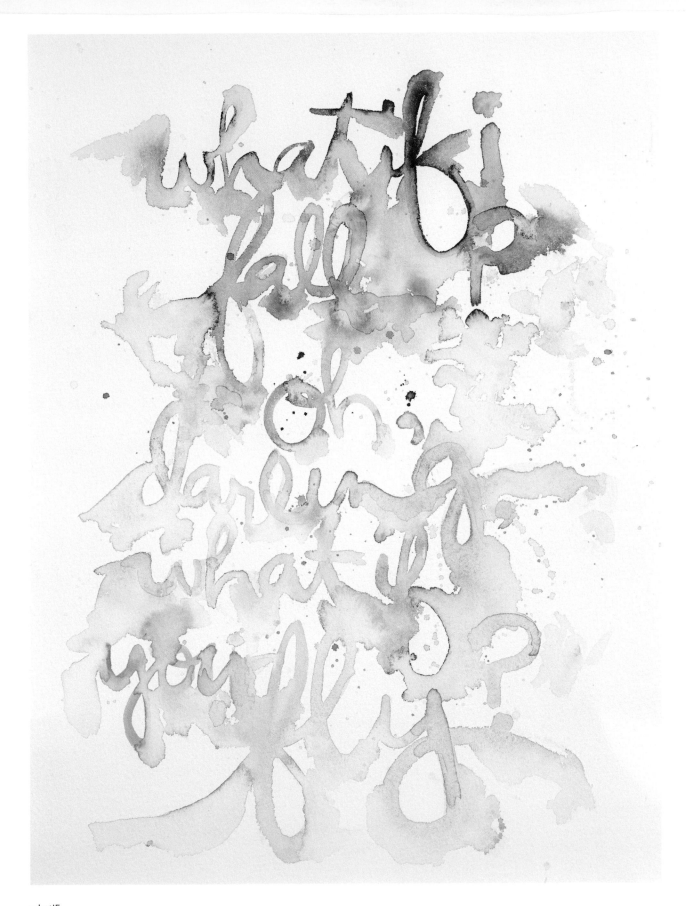

whatIF
Illustrated watercolor on paper.
Supplies used: pan watercolors and patience.
Techniques used: Moving through the rainbow to combine washes between words. And did I
mention lots of patience and practice? Lots.

index

a content + ecommerce company

Other fine North Light Books are available from your favorite bookstore, art supply store or online supplier. Visit our website at fwcommunity.com.

20 19 18 9 8 7 6

DISTRIBUTED IN THE U.K. AND EUROPE
BY F&W MEDIA INTERNATIONAL, LTD
Brunel House, Forde Close, Newton Abbot, TQ12 4PU, UK
Tel: (+44) 1626 323200, Fax: (+44) 1626 323319
Email: enquiries@fwmedia.com

ISBN 13: 978-1-4403-4012-3

Edited by Beth Erikson
Designed by Alexis Brown
Production coordinated by Jennifer Bass

about the author

Danielle Donaldson has walked a creative path for as long as she can remember. Her love of art began, as most young souls do, with a big box of crayons and a stack of coloring books. Over time, she focused her artistic efforts in watercolor and graphite drawing techniques, and eventually received her degree in graphic design. Her love of fine art, combined with her skills as a graphic designer, have provided her with an uncommon pairing of intuition and practicality, creating a careful balance between the stories she tells with her pencils and paints, and what others around her are drawn to.

While at home raising her children, Lauren and Clay, Danielle found the perfect hobby to satisfy her need to be creative: scrapbooking. She had the opportunity to be a regular participant in the scrapbook industry by publishing her art in magazines and how-to books, creating products for several companies and teaching at a national level.

Over the past decade she shifted away from the memory-keeping world and rediscovered her love of watercolors and graphite work, and the act of combining them with other mediums and techniques. Her use of big color palettes and delicately drawn details allows her to spin the ordinary into imaginative, balanced compositions. She continues to grow as an artist by fully embracing the creative process in all she does and with each story she tells. Danielle shares her process through social media, online classes and in-person workshops. You can learn more about Danielle, as well as her new work and upcoming classes, at danielledonaldson.com.

METRIC CONVERSION CHART

To convert	to	multiply by
Inches	Centimeters	2.54
Centimeters	Inches	0.4
Feet	Centimeters	30.5
Centimeters	Feet	0.03
Yards	Meters	0.9
Meters	Yards	1.1

alicia t.

christine p.

beth e.

cyndi s.

eliza

ann g.

clay d

dina m.

cindy f.

kirster m.

jessica g.

julie c.

lisa k.

lynn f.

jen o.

dad

lauren

madonna d.

jeanne

marilyn b

marianne e.

jill r.

kelly k.

jodi r.

jennifer s.

lindsay wo.

sarah.

sela f.

tanya a.

peter g.

scott

sara e.

serena b.

thank you

acknowledgments

Dad and Alicia: Thank you for being the best kind of family I could ask for and loving me always. And being proud of me. Oh. And for loving my art, of course.

Jill, Kelly, Jeanne, Marilyn, Jen and Michele: Thank you for being super dependable in an undependable world and for helping me let the multitude of colors on the inside burst on the outside in so many good ways. But most important, thank you for being you and letting me be me.

Sara: Thank you for teaching me about how to grow my art as a business—with patience, focus and consistency.

A special shout-out to Laura Worthington (lauraworthingtontype.com) for giving me the green light to use her lovely fonts in my book.

And to the plethora of creative souls in my little social media world, the staff at North Light, and my family and friends from the past, present and future: Thank you for being a part of all this goodness.

IDEAS. INSTRUCTION. INSPIRATION.

Receive FREE downloadable bonus materials when you sign up
for our free newsletter at CreateMixedMedia.com

Find the latest issues of *Cloth Paper Scissors* on newsstands, or visit ArtistsNetwork.com.

These and other fine North
Light products are available
at your favorite art & craft
retailer, bookstore or online
supplier. Visit our websites
at CreateMixedMedia.com
and ArtistsNetwork.tv.

Follow North Light Books for the latest
news, free wallpapers, free demos and
chances to win FREE BOOKS!

GET YOUR ART IN PRINT!

Visit **CreateMixedMedia.com** for up-to-date
information on competitions.